10th Anniversary Edition

How to Draw

Cool Stuff

SHADING,
TEXTURES
PATTERNS
OPTICAL ILLUSIONS

Catherine V. Holmes

Published by:
Library Tales Publishing
www.LibraryTalesPublishing.com
www.Facebook.com/LibraryTalesPublishing

ISBN-13:
9 7 8 1 9 5 6 7 6 9 7 3 9

Dedication

To Charlotte and Taya Cate

THE HOW TO DRAW *COOL* STUFF SERIES

How to Draw Cool Stuff shows simple step-by-step illustrations that make it easy for anyone to draw cool stuff with precision and confidence. These pages will guide you through the basic principles of illustration by concentrating on easy-to-learn shapes that build into complex drawings. With the step-by-step guidelines provided, anything can become easy to draw.

This book contains a series of fun, hands-on exercises that will help you see lines, shapes, spaces, and other elements in everyday objects and turn them into detailed works of art in just a few simple steps. The exercises in this book will help train your brain so you can visualize ordinary objects in a different manner, allowing you to see through the eyes of an artist. From photorealistic faces to holiday themes and tattoo drawings, How to Draw Cool Stuff makes drawing easier than you would think and more fun than you ever imagined! Now is the time to learn how to draw the subjects and scenes you've always dreamt of drawing.

WWW.HOWTODRAWCOOLSTUFF.COM

TABLE OF CONTENTS

Chapter 1
The Basics

Chapter 2
Shading

Chapter 3
Texture and Pattern

Chapter 4
Optical Illusions

Chapter 5
Cool Stuff

Why Art is Important

Visual art is a conversation, and drawing is your voice. What will you draw? What colors and materials will you use? What gets you excited? What story will your art tell? It's all up to you to decide **what you want to say.**

Learning to create and appreciate visual aesthetics is essential for the development of well-rounded individuals. An arts-rich experience offers many advantages. Along with a honed imagination and creative skills, active participants in the arts can express themselves and are open to new pathways for learning. Art can help us find confidence and self-discipline, appreciate the value of different cultures, think critically, solve problems, and make informed decisions.

Through drawing, many of these attributes are exercised. From the simple act of holding a pencil, which helps develop fine motor skills in young children, to an appreciation of ideas that deviate from the norm, art provides a vast array of opportunities to see and interpret the world. Looking at and discussing art encourages us to analyze—a hugely important skill. This allows us to experience our thoughts more fully and develop ideas more completely. The experience of making choices while creating art can carry over into other aspects of life, teaching us that problems can have more than one solution and that questions can have more than one answer.

CVH

"We encounter art every day in every aspect of our lives. From creative problem solving to self expression to the simple appreciation of beauty, creating art is a great way to improve concentration, express individuality and provide pleasure for yourself. Once an artist becomes engaged in the process of making something, beautiful and unique things can happen. Often times, this process is even more valuable than the outcome. The individual growth that happens as a result of making art never stops as long as there is a desire to create. The act of drawing is a way to pass the time, relax and offers an escape from reality. Always find the time to explore new ideas and enjoy the journey of creating."

CVHolmes

About the Author

Catherine V. Holmes is a teacher, artist, youth advocate, and author of the "How to Draw Cool Stuff" books which were originally intended as guides for her students and have gained worldwide recognition. She is also the mother of twin girls.

Holmes grew up in Plymouth, Massachusetts, where she took an interest in art from an early age. She specializes in portraits, architecture, and graphic illustration and has recently taken an interest in graffiti while incorporating text into her paintings.

Teaching, painting, drawing, and creating are Catherine's profession as well as her passion. She currently teaches art to elementary students in Massachusetts. A former teacher in the juvenile justice system, Holmes understands the need for art experiences in school to boost critical thinking while providing challenges for learners at all levels, connecting students with their own culture as well as with the wider world. Holmes has also taught at the middle school level and is an online instructor for Craftsy.com.

Catherine's art is inspired by her experiences and influenced by the varied interests and suggestions of her students. To see success through their eyes inspires her to be a better teacher and creator of art.

Catherine lives with her family near Boston.

FOREWORD

Welcome to 'How to Draw Cool Stuff: Basics, Shading, Texture and Pattern, Optical Illusions'—a guide for the enthusiastic artist. This book will help you tap into your creativity, improve your drawing skills, solve problems in new ways, appreciate the beauty around you, capture likenesses, express emotions visually, and draw some really cool things.

The subjects included are a sampling of the basics, shading, texture, pattern, optical illusions and, of course, *cool stuff*. The projects are easy to follow, starting from simple shapes and forms to more complex objects and designs.

To begin, try the basic exercises in Chapter One. Shape and form, which are used in the compositions of paintings and sculptures, are explored. Creating objects using basic forms simplifies the process of drawing and makes it easier to see what shapes make up a particular object. By drawing forms as part of an object, the artist is able to show depth as well as height and width.

One of the most realistic effects an artist can produce in order to make an interesting artwork is shading, discussed in Chapter Two. Shading is one of the easiest ways to add depth, contrast, character and movement to a drawing. There are several types of shading and many ways to go about doing it. This chapter will explain a few of these popular techniques.

Chapter Three explores a variety of texture and pattern ideas that can be included in an artwork. These are two of the elements and principals of art that help to add intrigue and depth to a design. These elements are necessary

to indicate the way something looks like it *feels* (texture) or create the repetition of *shapes*, *lines,* or *colors* (patterns).

The optical illusions outlined in Chapter Four involve images that are perceived to be different from what they really are. An optical illusion causes the brain to see one thing (or misinterpret what it sees) when the image is actually something completely different. The images in an optical illusion are examples of how the mind and the eyes can play tricks on each other. These drawings can be confusing and sometimes dizzying to look at but are always fun to create. Impossible objects are also explored: drawings that are possible to represent in two dimensions but are not geometrically possible in the physical world.

The final chapter is all about drawing "cool stuff". This is a random selection of items that my students have wanted to learn how to draw or have shown interest in. Specific exercises are provided that offer step by step guidelines for drawing a variety of subjects. Each lesson starts with an easy-to-draw shape that will become the basic structure of the drawing. From there, each step adds elements to that structure, allowing the artist to build on their creation and make a more detailed image. Some tutorials have more steps than others but all have been made as simple as possible. All you need is paper, a pencil and an eraser and you are ready to draw cool stuff. Once the drawing is complete, it can be colored, shaded or designed in any way you like to make it original. Following these exercises is a great way to practice your craft and start seeing things in terms of simple shapes within a complex object.

When perusing these chapters, there are a few tips to follow for a successful end product:

• Try not to skip any of the steps provided in each tutorial. It might appear faster to do so, but it is far more frustrating, especially for a beginner. Please, follow the sequence in order to achieve the best result.

• Draw lightly. Once the basic outline is drawn out, then lines can be made darker and more permanent. With a lighter hand, erasing becomes easier and fewer papers are crumpled up and thrown away.

• Your artwork does not need to look exactly like the one in the book. Try to make your work different from the images shown by adding "extras" and more details. This makes each work of art unique and personal.

- If a drawing seems to be too difficult or you are spending too much time on it without success, step away from it for a bit. Taking breaks will allow you to come back to the work with a fresh perspective.

- Try blocking out the areas of the tutorial that you are not currently working on. After one step is finished, uncover the next step and draw what you see. By blocking out the steps you are not working on, the artwork becomes less challenging to attempt. Continue uncovering each step one by one and adding to your artwork until it is complete. It is a simple tactic but it works by getting you to focus on just one action at a time.

- With a bit of time and effort, you can do this. Creating art is a process and you should not expect your drawing to be instantly amazing. Start off with the first step and build on it from there. Anything worth doing takes time – so take your time! Patience is necessary. Don't rush and practice patience. Look at your artwork and figure out the lines that work and the lines that don't. Change them as needed.

"How to Draw Cool Stuff" can help guide you through the creative thought process and provide plenty of ideas to get you started, but don't limit yourself to the confines of the book. Check out the lessons offered and take what you like from them. There are millions of cool things to draw out there and only a sampling are within these pages. The best cool stuff can be found in your imagination!

Chapter 1

The Basics

THE BASICS

Shapes and forms are found in nature and are also used in the composition of paintings and sculptures. The basic geometric shapes used in art are referred to as two-dimensional or 2D: having only width and height but no appearance of depth. Forms that are referred to as three-dimensional or 3D have the appearance of width, height, and depth. There are also organic shapes seen in artworks (also known as free-form or biomorphic shapes) that are frequently found in nature and do not have formal names.

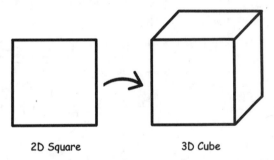

2D Square 3D Cube

A square is a two-dimensional (2D) shape that can be made into the three-dimensional (3D) form of a cube.

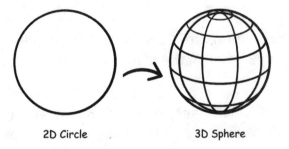

2D Circle 3D Sphere

A circle is a round, 2D shape in which every point on the outside is the same distance from the center. This can be made into the 3D form of a sphere that is shaped like a ball and circular from all possible points of view.

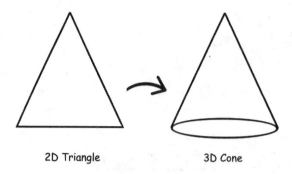

2D Triangle 3D Cone

The cone is a form that appears triangular at the tip yet round at the base, a 3D form having a surface created by a straight line (the side length) that tapers smoothly from a base to a point called the apex or vertex.

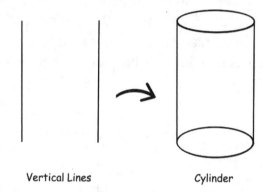

Vertical Lines Cylinder

The fourth basic form is the cylinder, a 3D geometric tube utilizing line and ellipse.

This chapter focuses on taking basic 2D shapes and drawing them so that they appear as 3D forms, the main forms seen within any realistic, three-dimensional drawing.

All forms, regardless of complexity, contain one or a combination of basic shapes. The four basic forms are Cube, Sphere, Cone, and Cylinder and their construction will be explored in the following pages.

Creating objects using basic forms simplifies the process of drawing and makes it easier to see what shapes make up that object. By drawing forms as part of an object, the artist is able to show depth as well as height and width.

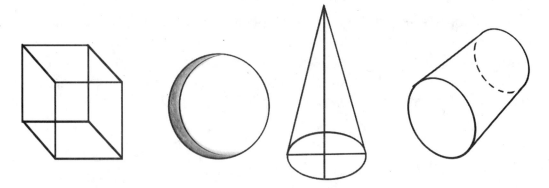

Shadows added to these forms make them appear more realistic and three-dimensional through the use of blending, contrast, highlights, and shading.

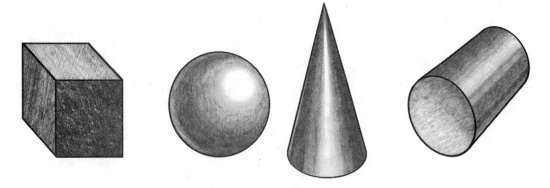

Once shading and light sources are confirmed, forms can then be turned into recognizable objects. Shapes and forms can be seen in almost every object imaginable. Although an object may not perfectly duplicate a specific form, these basic forms are present in some manner. The samples shown in "The Basics" chapter have forms present within them and are presented to show the possibilities a form has to offer within an artwork.

At the end of the chapter you will find a few exercises that review the basic construction of a generic human form. This chapter is short but very important when learning how to construct a basic outline for anything that you draw. With a bit of practice drawing and observing objects around you, soon you will be identifying simple shapes and forms within objects and arranging them intuitively to create original works of art.

A BASIC CUBE

KNOW:

A 3D cube (form) can be drawn from a 2D square (shape).

UNDERSTAND:

• Perspective
• The variety of ways to draw a 3D cube

DO:

Practice drawing cubes using the techniques provided.

VOCABULARY:

Cube – A symmetrical, three-dimensional shape contained by six equal squares.

Overlap – When one thing lies over and partly covers something else.

Parallel Lines – Two lines on a plane that never meet.

Perspective – The technique used to create the illusion of 3D onto a 2D surface. Perspective helps to create a sense of depth or receding space.

Vertical – The direction going straight up and down; the opposite of (or perpendicular to) horizontal. Any orientation neither vertical nor horizontal is diagonal.

Horizontal – The direction going side to side; the opposite of (or perpendicular to) vertical. Any orientation neither vertical nor horizontal is diagonal.

A Basic Cube

1. Draw a short vertical line with a longer horizontal crossing through.

Longer horizontal line Shorter vertical line

2. Connect the outer edges so it looks like a diamond shape.

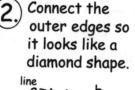

Lines "a" and "d" are parallel to one another. Lines "b" and "c" are parallel to one another. Erase the cross in the center after this step.

3. Extend the corner points as shown below.

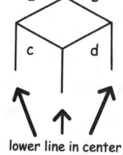

lower line in center, higher on sides

4. Close the bottom using angled lines as shown.

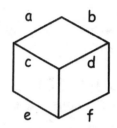

Lines "c" and "e" are parallel to one another. Lines "d" and "f" are parallel to one another.

More Angled

1. Create guide points.

Notice the center points are closer together.

2. Connect the dots to create the top of cube.

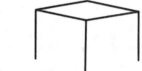

3. Extend sides as shown.

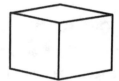

4. Close the bottom.

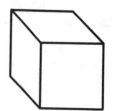

Or Try This

1. Draw a square.

2. Draw another square as shown.

one higher
one lower and moved over

3. Connect corners with straight lines.

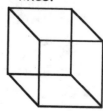

4. Erase the "inside" lines.

BASIC CONE

KNOW:

Cone, Ellipse, Perspective, Vertical

UNDERSTAND:

- The cone is one of the four basic forms that appear in nature and in man-made objects.
- There are several ways to draw a realistic-looking cone.

DO:

Practice the variety of methods shown to create a cone.

TIPS:

- Start with a vertical line to establish the center of the cone.
- Construct a triangle using that vertical line, which will bisect the triangle into two even halves.
- Attach an ellipse to the base of the triangle.

VOCABULARY:

Cone – A three-dimensional form having a surface created by a straight line (the side length) that tapers smoothly from a base to a point called the apex or vertex.

Ellipse – A circle viewed at an angle; an oval.

Perspective – The technique artists use to project an illusion of the three-dimensional world onto a two-dimensional surface. Perspective helps to create a sense of depth or receding space.

Vertical – The direction going straight up and down; the opposite of (or perpendicular to) horizontal. Any orientation neither vertical nor horizontal is diagonal.

Basic Cone

1. Start with a long vertical line with a short horizontal at the bottom as shown.

2. Draw an ellipse at the bottom to indicate the base of the cone.

3. Connect the top of the vertical line to each edge of the ellipse.

4. Erase all of the guidelines drawn in step 1.

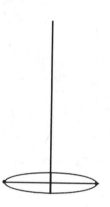
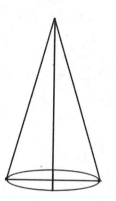

or this . . .

1. Start with a long vertical and short horizontal.

2. Connect the top of the vertical to the base as shown.

3. Draw a small line at the bottom and one inside as shown.

4. Use guides drawn in step 3 to create an ellipse.

5. Erase inside guides.

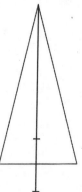
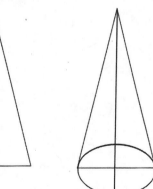
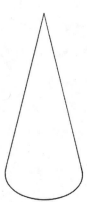

11

BASIC CYLINDER

KNOW:

Cylinder, Ellipse, Parallel, Perspective

UNDERSTAND:

- A cylinder is a circle that is projected into 3 dimensions. If you are looking directly at the top or bottom of a cylinder, all that is seen is a circle. The cylinder appears when viewing it askew or from the side.
- There are several ways to draw a realistic-looking cylinder.
- Vertical cylinders will have parallel lines, non-vertical cylinders can utilize One-Point Perspective.

DO:

Practice the variety of methods shown to practice drawing cylinders.

VOCABULARY:

Cylinder – A three-dimensional geometric form utilizing line and ellipse.

Ellipse – A circle viewed at an angle; an oval.

Parallel – Two or more straight lines or edges on the same plane that do not intersect. Parallel lines have the same direction.

Perspective – The technique artists use to project an illusion of the three-dimensional world onto a two-dimensional surface. Perspective helps to create a sense of depth or receding space.

Basic Cylinder

Short Cylinder

1. Start with two points.

point
↓
•

point
↓
•

2. Connect the points with rounded lines to make a thin oval.

3. Add 2 vertical lines directed straight down from both points.

4. Connect the base with a curved line.

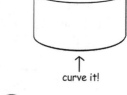

↑
curve it!

Long Cylinder

1. Start with two points.

point
↓
•

point
↓
•

2. Connect the points with rounded lines to make a thin oval.

3. Add 2 long vertical lines coming straight down from each point.

4. Connect the base with a curved line.

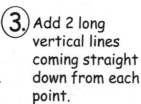

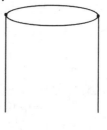

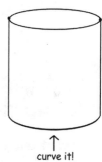

↑
curve it!

Stacked Cylinders

1. Start with a basic cylinder & add a point to both sides as shown for a guide.

point
↓
•

point
↓
•

↑
curve it!

2. Connect the points with rounded lines to make a thin oval.

erase dotted areas "behind" the first cylinder

3. Add 2 long vertical lines coming straight down from each point.

4. Connect the base with a curved line.

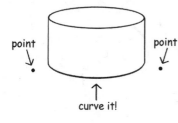

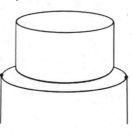

continue as desired . . .

Basic Cylinder 2

More ways to draw a cylinder . . .

Vertical

① Start with a vertical line with a short horizontal at top and bottom as shown.

② Draw an ellipse balanced equally at the top and bottom lines as shown.

③ Erase all lines drawn in step 1. These are only guidelines.

④ Connect top and bottom ellipses using horizontal lines.

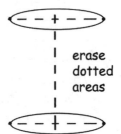

erase dotted areas

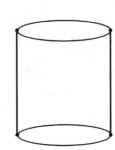

Non-Vertical

① Start with two ellipse shapes: a large one in front and a slightly smaller one above and to the right of the first.

② Connect the two ellipses with angled lines as seen below.

③ Erase the inside of the ellipse on the right (dotted area).

④ Final result should look similar to the cylinder below.

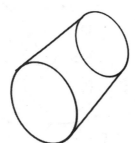

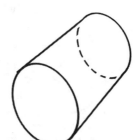

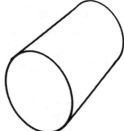

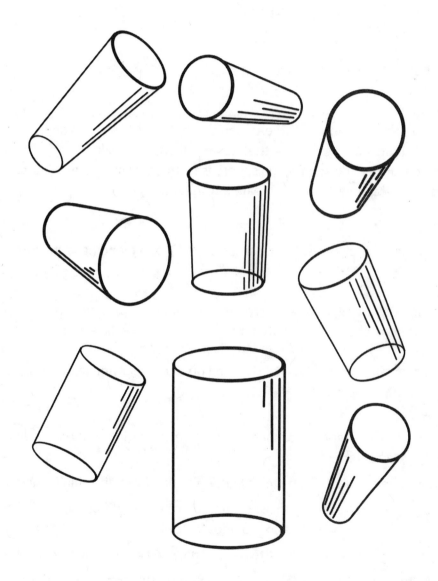

BASIC SPHERE

KNOW:
Circle, Light Source, Shading, Sphere

UNDERSTAND:
• Learning how to draw simple, three-dimensional shapes like cubes and spheres is great practice for artists looking to hone their technical drawing skills.
• When shading, the darkest area of a sphere is furthest from the light source.
• The lightest area can be erased to create a highlight.

DO:
Practice drawing basic spheres using learned shading and blending techniques.

NOTES:
• As you shade towards the light source, use less and less pressure with the pencil. This means using heavier pencil pressure on the dark areas and lighter pressure on the light areas.
• Indicate a direct light source so that deciding on dark areas and light ones will be easier.

VOCABULARY:

Circle – A round, two-dimensional shape in which every point on the outside is the same distance from the center.

Light Source – The direction from which light is coming from and shining on an object.

Reflected Light – When light bounces off an object and is diffusely reflected; light that bounces back into a shaded area and modifies its tone.

Shading - Showing change from light to dark or dark to light in a picture.

Shadow - A dark area cast by an object illuminated on the opposite side.

Sphere - A three-dimensional form shaped like a ball, circular from all possible points of view. Its surface consists of points, all of which are the same distance (radius) from its center.

Basic Sphere

1. Draw the outline of a circle with a light, sketchy line. You can use a compass, trace a round object or try drawing it freehand.

2. Draw a curve around the center

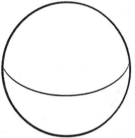

3. Draw a curve above and below the line drawn in step 2

4. Continue to add rings around the sphere until it is covered with stripes.

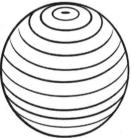

5. Draw a straight, vertical line as shown. Add curved lines on either side.

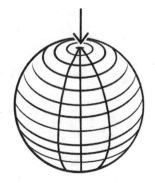

6. Continue to add curved lines around the sphere until it is covered. The 2D circle shape will now appear as a 3D form.

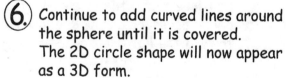

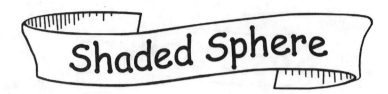

Shaded Sphere

① Draw a circle with a light, sketchy line. You can trace a round object, use a compass or try drawing it freehand!

② Choose a direction that the light source will come from.

This lamp indicates the light source is coming from the upper right

③ Start shading the area furthest from the light source. This will be the second darkest spot on the circle.

This slightly lighter area indicates reflected light

④ Shade toward the light source, adding a bit more pressure. This next shadow will be the darkest spot.

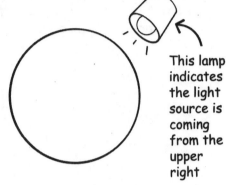

Add a very light circle in this spot to mark the lightest area

⑤ Continue to fill the circle using less pencil pressure as the shadow moves toward the light source.

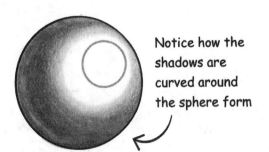

Notice how the shadows are curved around the sphere form

⑥ Leave a white area closest to the light source for a highlight.

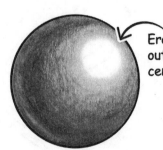

Erase or blend out the light center circle

7. Smooth tones with a blending tool. Make sure all outlines are removed.

8. Add an oval shadow beneath. The circle shape will now appear as a spherical, 3D form.

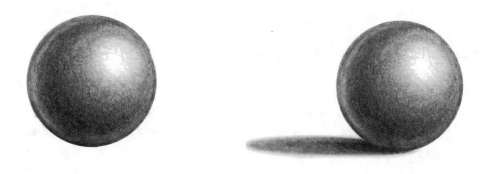

Shade your own!

SHADING FORMS

KNOW:

Blend, Contrast, Highlight, Shading, Shadows, Value Scale

UNDERSTAND:

• The lightness or darkness of a value can indicate where a light source falls on an object.
• Shading adds depth, contrast, character, and even movement to your drawings by capturing the shadows and highlights of your object.

DO:

Create a line drawing of each of the four basic forms (cube, sphere, cone, and cylinder) and shade them using the value scale as a guideline.

NOTES:

• Observe the object and shade it according to the value scale.
• Gently blending the light areas into the darker areas helps to create realistic shading.

VOCABULARY:

Blend – To mix marks or colors smoothly together on a surface. This is sometimes called feathering.

Contrast – A large difference between two things; for example, dark and light.

Highlight – The area on any surface that reflects the most light. Highlights and shadows are important to the achievement of realistic shading.

Shading - Showing change from light to dark or dark to light in a picture.

Shadow - A dark area cast by an object illuminated on the opposite side.

Value Scale - Values are the lights and darks of your drawing. A complete value scale will range from white all the way to black with many shades of gray in between.

Shading Forms

① Value Scale

make a rectangle with 5 squares

number them: 1 2 3 4 5

Shade the squares

leave white	light gray	medium gray	dark gray	black
1	2	3	4	5

② Flat Shading - CUBE

angle bottom

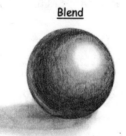

③ Round Shading - SPHERE

Add 3 more circles

highlight
mid-tone
shadow
reflected light

Shade

Blend

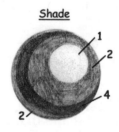

④ Cone

1. 2. 3. 4.

Shade Blend

5. 6.

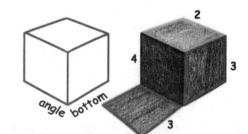

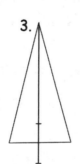

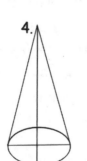

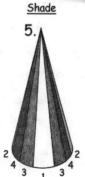

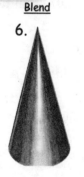

⑤ Cylinder

guide points

Shade Blend

TURNING FORMS INTO OBJECTS

KNOW:
• The four basic forms: Cube, Sphere, Cone, and Cylinder
• Blend, Contrast, Highlight, Shading, Shadows, Value Scale

UNDERSTAND:
• Value added to a shape (2D) when drawing creates form (3D).
• Most drawings and complex works of art can be broken down into basic shapes and forms.

DO: Take four basic forms (cube, sphere, cone, and cylinder) and turn them into recognizable objects and shade them.

NOTES: When drawing from life, observe the object you want to draw and determine what basic shapes/forms are needed to render the object.

VOCABULARY:
Cone – A three-dimensional shape that has a surface formed by a straight line (the side length) that tapers smoothly from a base to a point called the apex or vertex.

Cube – A symmetrical three-dimensional shape, either solid or hollow, contained by six equal squares; a polyhedron having six square faces.

Cylinder – A three-dimensional geometric shape utilizing line and ellipse.

Sphere – A three-dimensional form shaped like a ball, circular from all possible points of view. Its surface consists of points, all of which are the same distance (radius) from its center.

Shading – Showing change from light to dark or dark to light in a picture.

Shadow – A dark area cast by an object that is illuminated on the opposite side.

Value Scale - Values are the lights and darks of your drawing. A complete value scale will range from white all the way to black with many shades of gray in between.

Forms Into Objects

1. Cube into a present

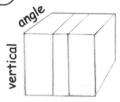 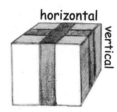 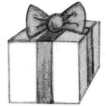

angle, vertical, horizontal, vertical

Start with a basic cube & draw ribbon lines.

Lightly shade the ribbon.

Shade top of cube very light. Shade the side slightly darker.

Add another shaded ribbon as shown.

Add a bow. See next page for bow detail.

2. Sphere into a Globe

 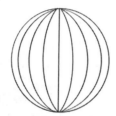 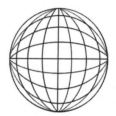 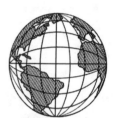

Start with a basic circle.

Add curved, vertical lines as shown. The center line is straight.

Add curved, horizontal lines as shown. The center line is straight.

Add continent shapes.

3. Cone into an Ice Cream

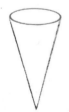 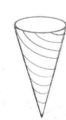 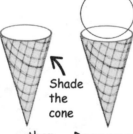 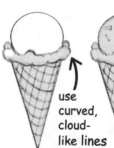 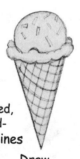 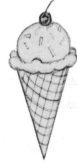

Shade the cone

use curved, cloud-like lines

Start with a basic cone.

Curve lines in one direction

. . . then the other.

Draw an oval at the top.

Connect oval to cone.

Draw sprinkles.

Add a cherry.

4. Cylinder into a Fire-Cracker

don't use a ruler - curve the lines a bit!

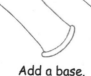 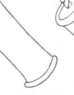

Draw cylinder at an angle.

Add a base.

Draw smaller oval inside top.

Add wick.

Add curved stripes.

Add sparks and shade.

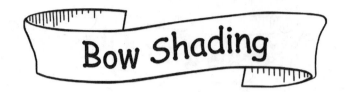

Bow Shading

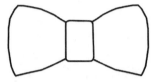

Start with a rounded rectangle at the center with curves coming from the sides to make the bow.

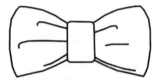

Add lines in the bow to show changes and folds in fabric.

Shade in the darkest areas of the bow first, including inside the fold creases and at the base.

Add the mid-tones.

Use a blending tool to smooth tones together.

Erase any dark outlines as well as the lightest areas of highlight.

HUMAN OUTLINE

KNOW:
- Simple shapes combined together can create more complex objects
- Layering, Overlapping
- Simple steps to create a realistic human figure

UNDERSTAND:
- Connecting simple shapes can aid in the drawing of a human figure.
- The basics of proportion to create a realistic human outline.
- Features of the adult human body can be measured/created on a grid (7 heads tall).

DO:
Construct a proportionate human outline starting with an advanced stick figure. Simplified forms of body parts can be added to the stick figure that focus on correct proportion, balance, and pose. Finally, connect all the body part shapes and erase the unnecessary lines inside to create a standard human body outline. Once this is done, the volumes can be exaggerated or changed to create a unique character.

NOTE:
You do not have to draw the "7 heads tall" guideline seen in step 1. That is just a sizing reference to indicate how much area will be needed to draw your figure.

VOCABULARY:

Layering – To place something over another surface or object.

Overlap – When one thing lies over, partly covering something else. This is one of the most important means of conveying an illusion of depth.

Proportion – The comparative relationship between two parts of an object (or the entire object) in terms of size, quantity, degree, or number.

Tip: For fun, refer to the human body parts as types of candies and call him "The Candy Man."

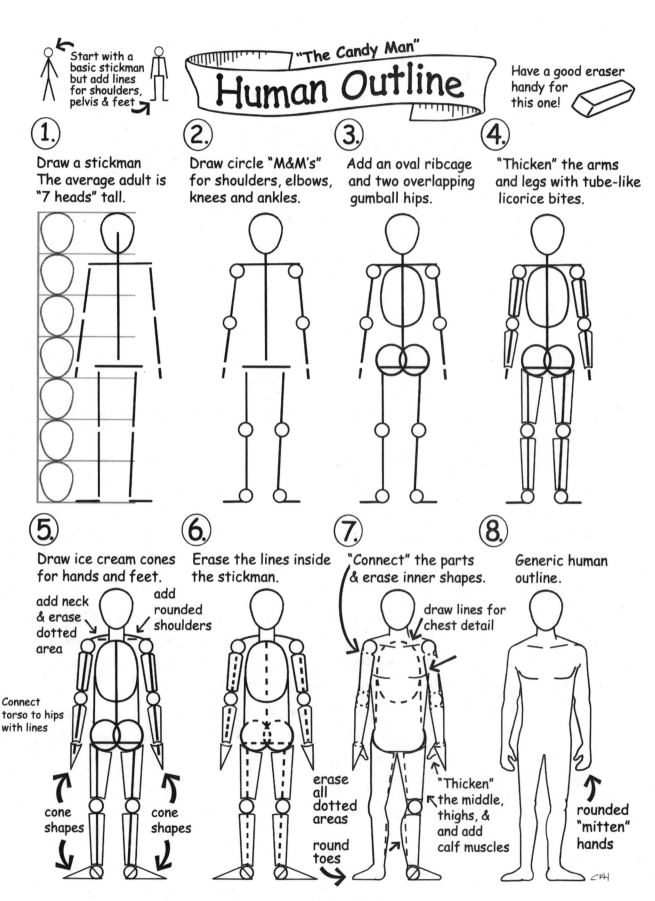

Start with a basic stickman but add lines for shoulders, pelvis & feet

"The Candy Man"
Human Outline

Have a good eraser handy for this one!

1. Draw a stickman The average adult is "7 heads" tall.

2. Draw circle "M&M's" for shoulders, elbows, knees and ankles.

3. Add an oval ribcage and two overlapping gumball hips.

4. "Thicken" the arms and legs with tube-like licorice bites.

5. Draw ice cream cones for hands and feet.

add neck & erase dotted area

add rounded shoulders

Connect torso to hips with lines

cone shapes

cone shapes

6. Erase the lines inside the stickman.

erase all dotted areas

round toes

7. "Connect" the parts & erase inner shapes.

draw lines for chest detail

"Thicken" the middle, thighs, & and add calf muscles

8. Generic human outline.

rounded "mitten" hands

CVH

HUMAN OUTLINE VARIATIONS

KNOW:
• Simple shapes combined together can create more complex objects
• Layering, Overlapping
• Simple steps to create a realistic human figure

UNDERSTAND:
• Connecting simple shapes can be the first step to creating a basic human figure.
• Features of the adult human body can be measured/created on a grid (7 heads tall).
• Features of the child/baby human body can be measured/created on a grid (4-5 heads tall).
• Making shapes smaller or larger can be effective in creating a unique character.

DO: Construct a unique human outline using the tips and tricks provided. Simplified forms of body parts can be added to the stick figure that focus on correct proportion, balance, and pose. Notice the differences in size and shape for the individual characters highlighted in the tutorial.

VOCABULARY:

Anatomy – The study of body structure, whether human or animal, including the bones, the muscles, and all the other parts. Knowledge of anatomy is important when drawing and sculpting both human and animal figures.

Layering – To place something over another surface or object.

Overlap – When one thing lies over, partly covering something else. Depicting this is one of the most important means of conveying an illusion of depth.

Proportion – The comparative relationship between two parts of an object (or the entire object) in terms of size, quantity, degree, or number.

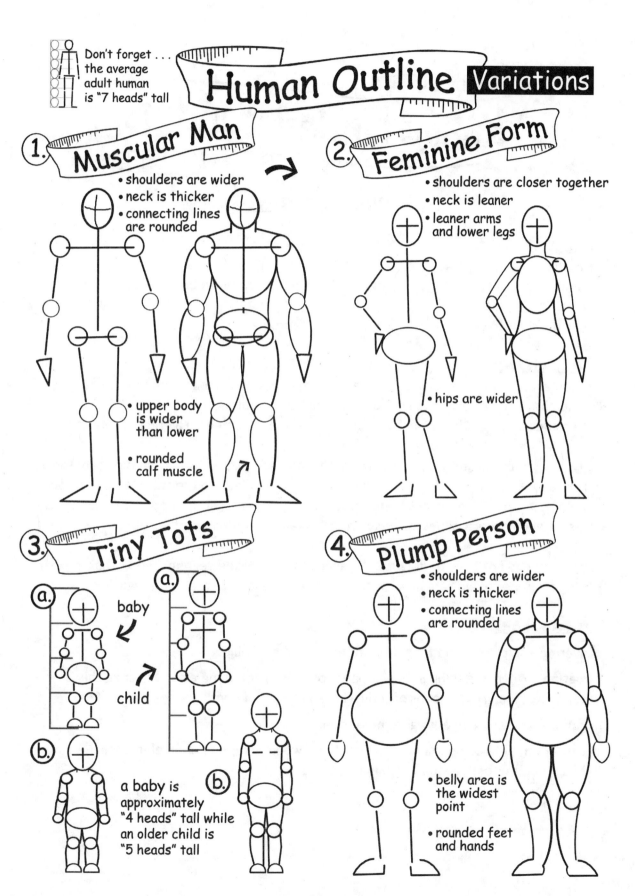

Don't forget . . . the average adult human is "7 heads" tall

Human Outline Variations

1. Muscular Man

- shoulders are wider
- neck is thicker
- connecting lines are rounded
- upper body is wider than lower
- rounded calf muscle

2. Feminine Form

- shoulders are closer together
- neck is leaner
- leaner arms and lower legs
- hips are wider

3. Tiny Tots

a.

baby

child

a.

b.

b.

a baby is approximately "4 heads" tall while an older child is "5 heads" tall

4. Plump Person

- shoulders are wider
- neck is thicker
- connecting lines are rounded
- belly area is the widest point
- rounded feet and hands

HUMAN PROFILE

KNOW:
- Profile
- Simple shapes combined together can create more complex objects
- Layering, Overlapping
- Simple steps to create a realistic human figure profile

UNDERSTAND:
- Connecting simple shapes can be the first step to creating a basic human figure.
- The basics of proportion to create a realistic human outline.
- Features of the adult human body can be measured/created on a grid (7 heads tall).

DO: Construct a proportionate human profile outline starting with the basic head, torso, arms, and legs. Simplified forms of body parts can be added to the stick figure that focus on correct proportion, balance, and pose. Finally, connect all the body part shapes and erase the unnecessary lines inside to create a standard human profile outline.

NOTE: You do not have to draw the "7 heads tall" guideline seen in step 1. That is just a sizing reference to indicate how much area will be needed to draw your figure.

VOCABULARY:

Layering – To place something over another surface or object.

Overlap - When one thing lies over, partly covering something else. Depicting this is one of the most important means of conveying an illusion of depth.

Profile – A view of something from the side.

Proportion – The comparative relationship between two parts of an object (or the entire object) in terms of size, quantity, degree, or number.

No ruler needed.
The straight lines are
for guides only and will
eventually be erased.

Human Profile

Have a good eraser
handy for
this one!

1.
Draw a circle on
a stick with feet.

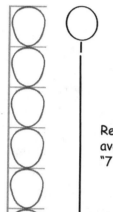

Remember, the
average adult is
"7 heads" tall

2.
Add circles for
shoulders, elbows,
knees and ankles.

Draw a small
triangle for
the chin area

Add a bent arm
and circles for
shoulder, elbow,
knee and ankle
joints

3.
Add a rounded rib
cage and a circle
for the pelvis.

4.
"Thicken" the arms
and legs as shown.

Upper arm
is thicker
than
forearm

Thigh area
is thicker
than lower
leg

Bump for
calf muscle

5.
Erase lines inside
the stickman.

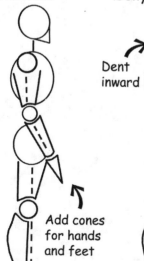

Add cones
for hands
and feet

6.
Connect neck and
belly as shown.

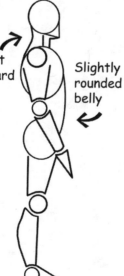

Dent
inward

Slightly
rounded
belly

7.
"Connect" the body
parts & erase guides.

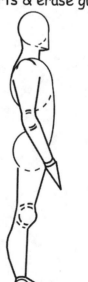

8.
Generic human
outline.

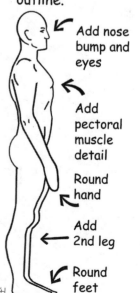

Add nose
bump and
eyes

Add
pectoral
muscle
detail

Round
hand

Add
2nd leg

Round
feet

Chapter 2

Shading

SHADING

Shading is one of the easiest ways to add depth, contrast, character, and movement to your drawings. Shading captures the shadows and highlights within an image to help make an artwork more realistic and interesting. There are several types of shading and many ways to go about doing it. This chapter will explain a few of these techniques.

Most of the shading discussed in the following pages utilizes the pencil. This book was created to provide interesting and informative lessons without the need for expensive or multi-dimensional supplies: a regular pencil, paper, and eraser are all that is needed for a successful drawing. The pencils marked with "HB," "2HB," or "2" are the regular, all-purpose pencils that are most common. These are the pencils that you are most likely to use in school or at work.

There are, however, specialized artist pencils available for complex shading projects. Specialized artist pencils come in two major graphite categories. These categories are labeled as "H" or "B" and they measure the hardness (H) or softness (B) of the marks made by the pencil's core. Along with the "B" or "H" letter grade, the graphite will also have a number next to that letter to indicate just how soft or hard its mark is.

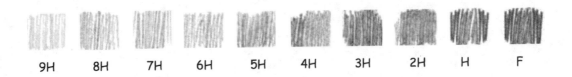

9H 8H 7H 6H 5H 4H 3H 2H H F

"H" Graphite Pencil Grading Scale

"H" stands for "hard" and refers to a hard graphite pencil. Hard pencils leave lighter, thinner marks and can sharpen to a very fine tip. These pencils are usually labeled with a number to indicate the degree of hardness followed by the letter H. Generally, the higher the number, the lighter and thinner the mark will be. A 9H pencil will leave a mark that is much lighter and thinner than a 2H. Some scales will show an "F" grade between the "H" and the "HB." "F" often indicates "fine," "fine point," or "firm.

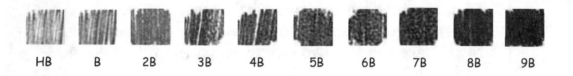

HB B 2B 3B 4B 5B 6B 7B 8B 9B

"B" Graphite Pencil Grading Scale

"B" stands for "soft" and refers to a pencil that has soft graphite. Soft pencils leave darker, thicker, smudgy marks. These pencils are usually labeled with a number to indicate the degree of softness followed by the letter B. The higher the number, the softer and darker the mark will be. A 9B pencil will leave a mark that is much more smudgy and dark than a 2B. Softer pencils will dull faster than harder pencils and usually require more frequent sharpening. As you can see by each chart, the scale goes up to 9 at each end, 9B being the softest and 9H being the hardest graphite. Both of these extreme ends of the scale are often too light or too dark for regular use.

Artists sometimes use a range of different pencil types in one drawing to render different effects. A hard pencil is often used for outlining or fine mechanical work while softer pencils, which allow for easy blending, are used for shading. Remember, these pencils are not necessary for you to be able to draw cool stuff. If only regular pencils are available – that is fine!

HB/2/2HB is by far the most common type of pencil out there and is most likely the one you will use.

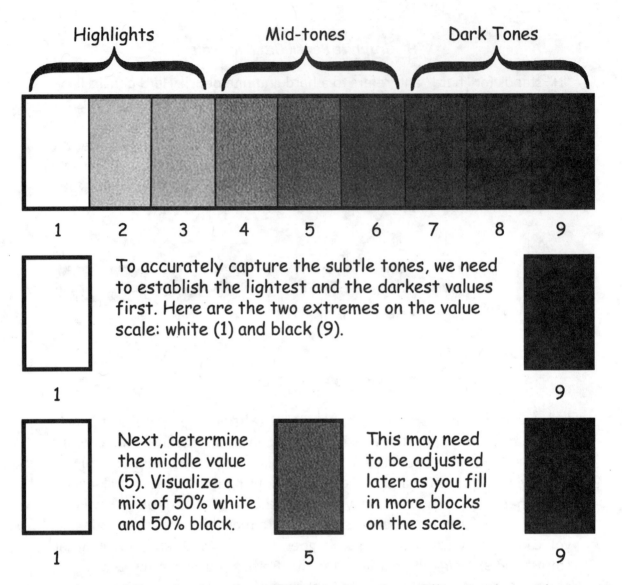

Highlights Mid-tones Dark Tones

1 2 3 4 5 6 7 8 9

To accurately capture the subtle tones, we need to establish the lightest and the darkest values first. Here are the two extremes on the value scale: white (1) and black (9).

1 9

Next, determine the middle value (5). Visualize a mix of 50% white and 50% black.

This may need to be adjusted later as you fill in more blocks on the scale.

1 5 9

Once the middle value has been filled in, continue filling in the scale starting with the dark end (value 8) or the lighter end (value 2), working towards value 5.

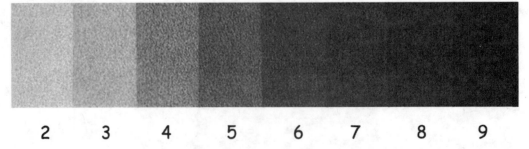

1 2 3 4 5 6 7 8 9

Tip: As you work, evaluate the accuracy of your values. Values that are side by side should be similar enough to almost merge together when you squint your eyes.

Try creating a value scale. Start with nine boxes, filling them in from light to dark, increasing your pencil pressure as you move toward the black. This exercise will help train your eye to see subtle value changes. It may take some practice, but it will aid in convincingly creating form, depth, space, and atmosphere in your drawings.

Once you have practiced shading with a value scale, you will need a drawing of an object to shade. This should be drawn lightly so any mistakes can be easily erased if needed. Also, if your sketch is to be realistically shaded, light outlines are best, not dark, since objects in real life are not outlined.

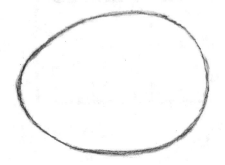

Here is a light contour drawing of an egg shape.

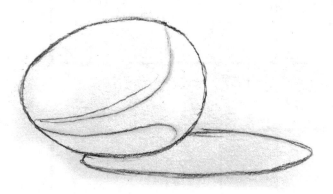

Have your value scale handy to help determine what to do next. Then, draw lines to mark off the dark and light shadow areas of the egg that we will add tone to. These are guidelines that will help determine which value scale tones will go where.

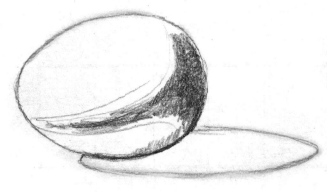

Now it is time to add value. The values on the egg may not be as dark as the darkest tone on the value scale, but they can be close. Start light and choose a 6 or 7 to fill in only the darkest area of the egg. This is seen as a claw shape across the center.

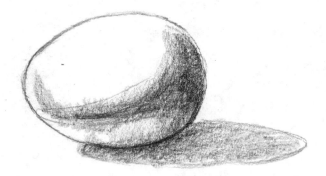

Lightly press down on the areas of the artwork that have the deepest shadows. This is just the beginning process, so there is no need to draw too dark too quickly. By keeping the initial shading somewhat light, erasing areas of highlight (or mistakes) will be much simpler.

When drawing a subject from life or a photo, it is important to locate the direction in which the light is coming from since we will be shading away from the light source; the brightest (lightest) areas will be those closest to the light, and the darkest areas will be the furthest away. The light source on our egg is coming from the left.

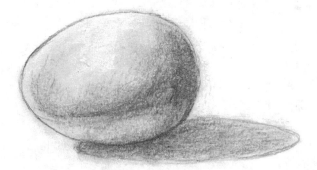

Once all the tones are laid down, an artist may choose to blend the tones together for a smooth appearance. Fingers, cotton swabs, or blending stumps can be used for this step. This will smooth out any rough edges and make the shading more gradual and realistic. Just beware of making mud! Rubbing too much will cause all those fine lines and contrasting shades to smudge together and become the same muddled, flat gray tone. This takes the depth away from a drawing and makes the work appear less detailed. For best results when shading with the finger rub technique, just smudge a little!

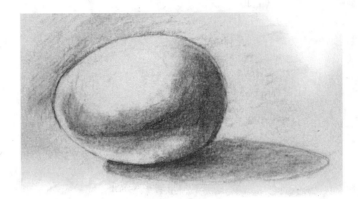

Use a kneaded eraser to remove any pigment that may have smudged the highlights during the blending process. Add some tone to the background to make the egg stand out more and to make the lightest spots appear whiter. The very brightest parts of the drawing should stay white to create highlights or reflections. If blending was done on the drawing, chances are the lighter areas have become smudged with some residual blending. This is easily fixed by gently erasing those smudged areas. Glares and reflections tend to be the brightest parts of a subject, so be sure to indicate these areas in the artwork.

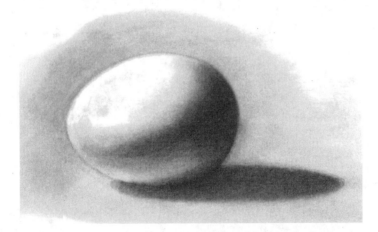

Continue blending for a smooth finish. Use the kneaded eraser to pull up any pigment that has smudged. Use it to also lighten any areas of highlight.

TIPS:

- When drawing from a photo, consider converting it to grayscale to use as a reference (make a copy of it using a copy machine on the photo setting). This will help the artist realize accurate shading since the object will already be in black and white.

- Having a hard time determining the dark areas from the lighter ones? Squint your eyes and these areas will become more evident.

- Using heavy pressure with your pencil will leave dark lines, while light pressure will leave light marks. A combination of both with a gradual transition from one to the other is one approach to realistic shading. Practice using different pencil pressures to create a variety of tones.

- Remember to be careful if you choose to smudge your artwork to create shading effects. When done properly, smudging can be a quick and effective way to add depth to an artwork; however, the technique of smudging an artwork with a finger to create shadows can blur some intricately drawn lines and ruin a beautiful drawing. A good rule of thumb: don't rub more than three swipes!

- If available, use different grades of pencils from hard (H) to soft (B). This can make drawing with value easier. By letting the pencils do some of the work, you won't have to press as hard with the pencil to achieve dark values. This also offers more control when adding light values.

- Why is value needed in a realistic artwork? Value is a very important aspect of a drawing, perhaps even more important than color when it comes to the design and success of an artwork. Darkness and lightness are used to create a focal point within a painting or drawing. These are areas that a viewer immediately looks at. A light element against a dark element creates contrast that is pleasing to the eye. Not only does value create a focal point, it also offers a three-dimensional illusion of form to subject matter.

Hatching

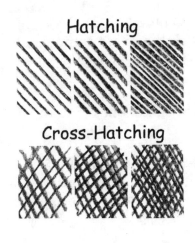

Cross-Hatching

Hatching and **cross-hatching** are valuable tools for generating value and texture in a drawing, and they work just as easily in pencil or pen. Areas where hatching is put in a drawing will appear darker or to be in shadow. Areas without marks will appear as highlights. In the example above, all of the hatching is at a diagonal angle; however, hatching can be drawn at any angle. This method is one of the quickest and most effective ways to vary density and darken value in a drawing, by creating a richer overall feel to a drawing. Cross-hatching can be applied as simple straight lines, just like parallel hatching, or it can follow the contours of the subject. When this method is done well, the close marks will appear to blend together from a distance.

Stipple

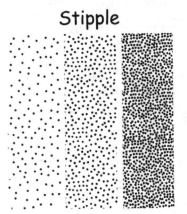

Stipple is a method used in drawing, painting, or engraving that uses dots rather than lines to create shading. This is a great way to add darkness quickly and easily while also adding texture. By "dotting" a pattern of points that are close together, the varying degrees of solidity in an object are represented.

The denser the dots, the darker the apparent shade. Stippling is mainly done in ink drawings, not pencil. The depth of tone and the roughness of texture can be changed by varying the density and distribution of the dots.

The best way to learn any of these techniques is to practice and experiment with them as often as you can.

Quick and Simple Shading

When shading an object without a specific light source, there are a few tips and tricks to use to quickly create shadows and depth.

There are more technical and detailed ways to shade an object, however, below are two methods that are quick and simple. Try them both!

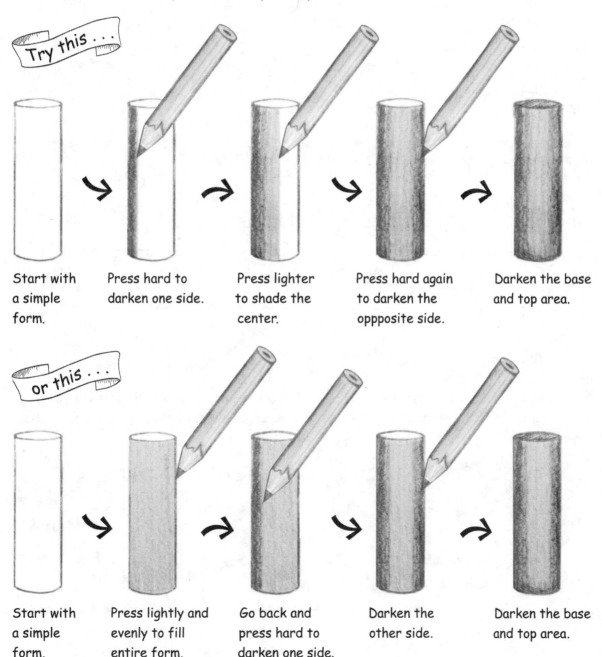

Try this . . .

Start with a simple form.

Press hard to darken one side.

Press lighter to shade the center.

Press hard again to darken the oppposite side.

Darken the base and top area.

or this . . .

Start with a simple form.

Press lightly and evenly to fill entire form.

Go back and press hard to darken one side.

Darken the other side.

Darken the base and top area.

When shading quickly or from memory without a specific light source, it makes sense to have darker shaded areas at the bottom of the object and lighter areas near the top.

top ↘

bottom ↗

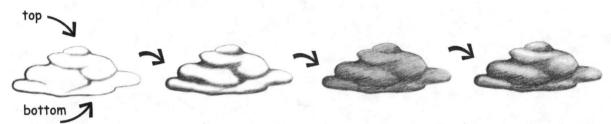

For example, even an organic blob has a top and a bottom.

Darken the areas underneath each blob curve.

Shade the remaining areas lighter.

Erase some areas near the very top of each curve for a highlight.

Another example can be seen in this bowl. . .

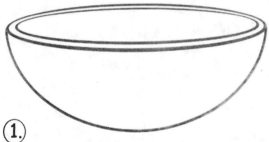

①.
Start with this basic bowl shape using a 1/2 oval and an ellipse. (Don't forget the inner "thickness" rim of the bowl.)

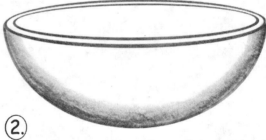

②.
Darken just the outer edges of the bowl using a curved motion. Follow the curve of the base.

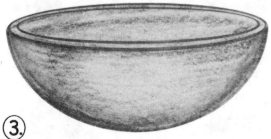

③.
Shade the remaining areas of the bowl lightly until it is completely filled in.

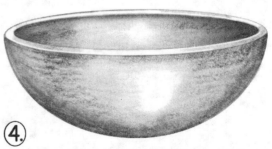

④.
Darken each side of the inside area of the bowl and erase spots on the rim and centers as shown to create a highlight.

REMEMBER RIBBON

KNOW:

Curve, Line, Overlapping, Shading

UNDERSTAND:

• How to create an effective design using simple shapes.

• How to create the illusion of depth and layers so that parts of a drawing appear to be in front of or behind other parts.

DO:

Follow the steps to create the image of a "Remember Ribbon." The overlapping will indicate which parts of the ribbon appear to be on top (in front) and which parts appear to be on the bottom (behind).

VOCABULARY:

Blend – To mix marks or colors smoothly together on a surface. This is sometimes called feathering.

Curve – A line or edge that deviates from straightness in a smooth, continuous way; or something that has the shape of a curve, such as an arc.

Line Art – An image that consists of distinct straight and curved lines on a plain background without gradations in shade or color.

Overlap – When one thing lies over another and partially covers it. Depicting this is one of the most important means of conveying the illusion of depth in a drawing.

The pink ribbon is an international symbol of breast cancer awareness.

 Remember Ribbon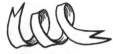

①

Start with an oval.

②

Add a triangle or cone shape below.

③ curve slightly — erase dotted

Erase the bottom of the oval then add 2 lines above the oval as shown.

④ Connect with a curved line

Extend one cone line diagonally.

⑤

Extend the other cone line so an "X" shape is made.

⑥ Draw two lines at a slight angle.

⑦

Draw two more diagonal lines extending from the angled lines.

⑧ Erase dotted

Close ribbon ends with diagonals.

REMEMBER RIBBON WITH SHADING

KNOW:
Blend, Shading

UNDERSTAND:
How to create the illusion of shadows and light in a drawing.

DO:
After drawing the "Remember Ribbon," start the shading process and capture the shadows and highlights on the ribbon. Follow the steps to gradually add light layers of tone.

VOCABULARY:

Blend – To mix marks or colors smoothly together on a surface. This is sometimes called feathering.

Shading – Showing change from light to dark or dark to light in a picture by darkening areas that would be shadowed and leaving other areas light. Blending of one value into another is sometimes called feathering. Shading is often used to produce illusions of dimension and depth.

 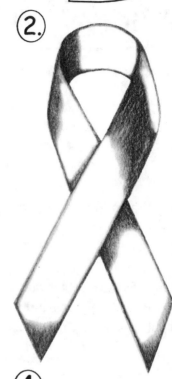

Remember Ribbon

with shading

1.

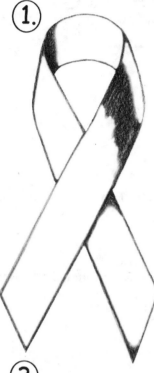

Use the basic remember ribbon and shade in the darkest areas. These areas are usually where there is overlapping and on the areas that are farthest from the light source.

In this case, the light source is coming from the left.

2.

Lightly shade the areas next to the darkest shadows (done in step one). The two shades should appear to blend into one another.

3.

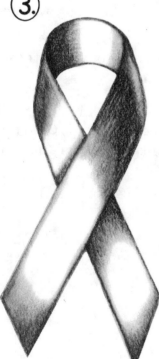

Extend the shading further down the ribbon by adding a slightly lighter shade next to the medium shadows created in step 2. The shading should still blend into one another.

4.

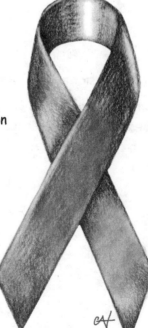

Finally, mix all of the shades together so they seamlessly blend into one another. Erase areas where the light reflects brightly to indicate highlights.

SOAP BUBBLES

KNOW:
Cross Contours, Curved Lines, Reflection, Shading, Sphere

UNDERSTAND:
Lines and shapes drawn in a curved manner on top of a circle shape help to create the illusion of a sphere.

DO:
- Create a drawing of soap bubbles that appear 3D by indicating cross contour lines around the circle to serve as reflections and shading.
- Draw several bubbles of varying sizes for a realistic effect.

VOCABULARY:

Overlap – When one thing lies over, partly covering something else. Depicting overlap is one of the most important means of conveying an illusion of depth.

Reflection – An image given back by a reflecting surface, such as that of a mirror or still waters.

Sphere – A three-dimensional ball form, circular from all points of view.

Cross Contour Lines – Drawn lines which travel across the inside of the form. Cross contour lines may be horizontal or vertical, or both, but always describe the form (three-dimensionality of an object or surface).

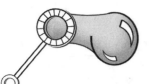

Soap Bubbles

What color is a bubble?

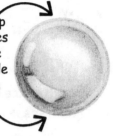

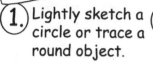

Simple Bubble

1. Lightly sketch a circle or trace a round object.

2. Draw two curved rectangles inside the circle.

3. Lightly shade inside contour of the circle.

leave a white rim

4. Gently smudge with finger.

clean up smudges outside of circle with an eraser

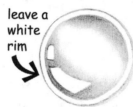

Detailed Bubble

1. Lightly sketch a circle or trace a round object.

2. Draw rounded lines that curve inside the bubble.

3. Lightly shade to connect lines as shown below.

4. Darken shading.

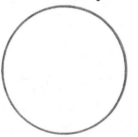

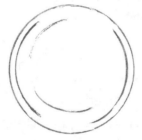

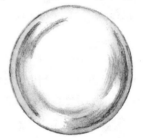

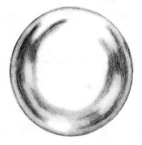

5. Connect with shading in the center.

6. Gently smudge with finger.

7. Add rounded rectangles and erase areas for highlights. Keep smudging and erasing until it looks good.

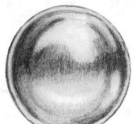

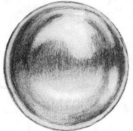

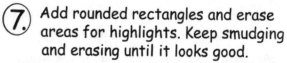

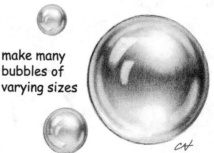

make many bubbles of varying sizes

highlights should be on the same side of each bubble

SIMPLE SNAIL

KNOW:

Curve, Line Art, Spiral

UNDERSTAND:
- How to create an effective design using simple shapes.
- Simple shapes combined together can create more complex objects.

DO: Create a line drawing of a snail using simple shapes and curves.

NOTES:
- This tutorial shows how to create a neat spiral using a series of circles. Try this method and then try to free hand a spiral (see below). See which one works best for you.
- Draw lightly so the guidelines are easy to erase.

VOCABULARY:

Curve – A line or edge that deviates from straightness in a smooth, continuous way or, something that has the shape of a curve, such as an arc.

Line Art – An image that consists of distinct straight and curved lines on a plain background without gradations in shade or color.

Snail – A small gastropod mollusk animal that lives in a shell that it carries on its back, that moves very slowly, and that can live in water or on land.

Spiral – A line that winds or circles around a central point, usually getting closer to or farther away from that point.

Freehand Spiral

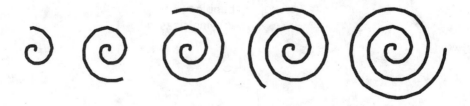

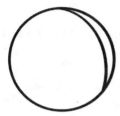 spiral

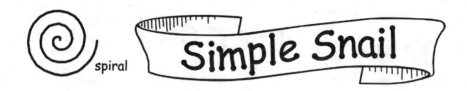
Simple Snail

1. Start with a circle. Add a small crescent as shown.

2. Draw a circle inside the previous one. It should be off center in the lower left area.

3. Connect that smaller circle to the outer circle with a curve. Erase dotted area.

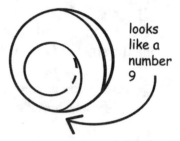

looks like a number 9

4. Add a smaller circle inside the middle circle as shown.

5. Connect small circle and middle circle with a curved line.

6. Add another small circle as shown. Erase dotted area.

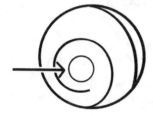

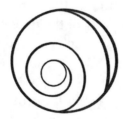

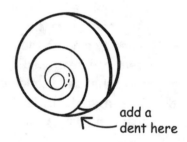

add a dent here

7. Draw one last tiny circle that touches the top of the last circle. Erase dotted area.

8. Add a rim to the front of the shell as shown.

9. Add body, head and eyestalks on the right and triangle tail on the left.

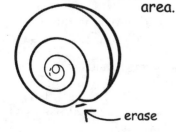

erase

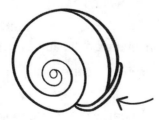

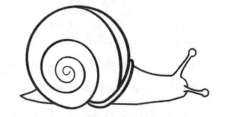

SHADED SNAIL

KNOW: Blend, Combine, Curve, Overlap, Value Scale

UNDERSTAND:
Shading adds depth, contrast, character, and even movement to your drawings by capturing the shadows and highlights of your object.

DO: Once you have created your spiral snail drawing, add details and shading using the tips and tricks provided.

NOTES:
• Typical school pencils are HB, which is a middle ground of hardness/softness. You can use an HB pencil if it is all you have available, but softer pencils (3B, 4B, 5B, etc.) will be easier to work with.
• Use light pencil lines so that they can be easily erased if needed.
• Pay special attention to any glares or reflections on the snail as those areas are the lightest areas. Leave the very brightest parts of the drawing white.
• When beginning the shading process, don't use the full darkness of the pencil so that areas can be erased or moved easily. This means press lightly and only sparingly fill in areas that need shading.
• Darken gradually, each time laying a thin layer of shade. The contrast between light areas and dark areas should become more clear and distinct.

VOCABULARY:
Blend – To mix marks or colors smoothly together on a surface. This is sometimes called feathering.

Curve – A line or edge that deviates from straightness in a smooth, continuous way, or something that has the shape of a curve, such as an arc.

Overlap – When one thing lies over, partly covering something else. Depicting this is one of the most important means of conveying an illusion of depth.

Spiral – A line that winds or circles around a central point, usually getting closer to or farther away from that point.

Value Scale - Values are the lights and darks of your drawing. A complete value scale will range from white all the way to black with many shades of gray in between.

see previous page for simple snail or try this variation

Shaded Snail

① Start with a circle.

② Add an overlapping oval to the left as shown.

③ Add another oval. Erase the overlapping pieces that are no longer needed.

erase dotted area

Draw a triangular curve here and extend it into the snail shell

slight overlap

④ It should look something like this

⑤ Add a number 6 shape inside the small oval.

⑥ Draw a spiral inside the "6" shape.

erase area indicated by dotted line

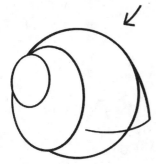

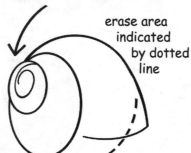

connect with curve

⑦ Draw a curved body beneath the shell.

⑧ Draw the head features.

See next page for shading details . . .

tentacles

head

mouth

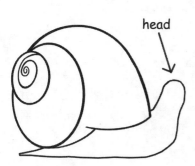

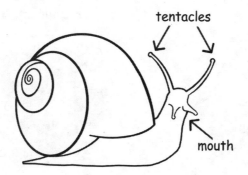

Shaded Snail

shade using value scale

1. Start to shade in the darkest areas of tone first.

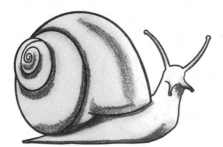

2. Add a light layer of tone over the whole snail.

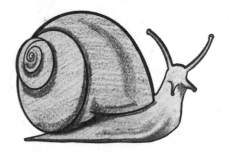

3. Use a blending tool to smooth tones.

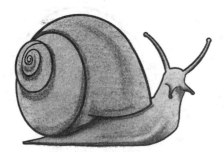

4. Use an eraser to remove pigment from the lightest areas.

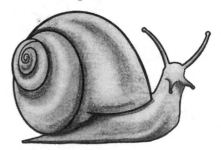

5. Use a sharp pencil to draw cross contour lines on the body.

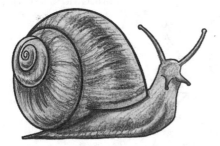

6. Lightly shade the rest of the snail. Rub with finger to smudge if desired. Use eraser to highlight shiny spots.

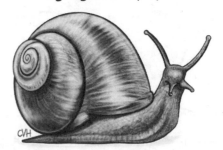

SIMPLE DAISY

KNOW:
- Simple shapes combined together can create more complex objects
- The steps to create a simple daisy
- Radial Balance, Repetition, and Rotational Symmetry

UNDERSTAND:
- Connecting simple shapes can be the first step to creating a recognizable, complex form
- A simple daisy is based on a circle with its design extending from (or focused upon) its center
- How to arrange elements in an artwork so that they appear symmetrical or equally balanced

DO:
- Follow the steps provided to create an original Simple Daisy design focusing on rotational symmetry.
- Shade with pencil or colored pencil.

VOCABULARY:

Balance – A principle of design, balance refers to the way the elements of art are arranged to create a feeling of stability in a work; a pleasing or harmonious arrangement or proportion of parts or areas in a design or composition.

Radial or Rotational Balance – Any type of balance based on a circle with its design extending from or focused upon its center.

Rotational Symmetry – An object that looks the same after a certain amount of circular movement around that object's center.

Symmetry – An object that is the same on both sides.

A Simple Daisy

1.

2.

3.

Start by lightly drawing a big circle and add a smaller circle in the center for the "eye" of the flower.

TIP: try and find some circles to trace!

Draw equally spaced lines crossing through the center of the small circle (looks like pizza slices). These lines will be guides for each petal.
It doesn't have to be perfect, just get it close.

Erase the marks inside the smaller circle then draw a curve as seen above next to each line. This will be 1/2 of each petal.

4.

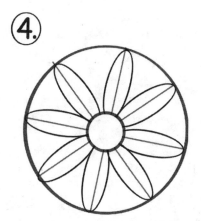

5.

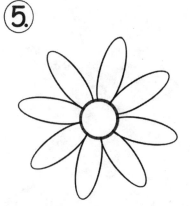

See the next page for shading details . . .

Complete each petal with a curve on the opposite side of the center lines. The petals should look like long, lean ovals that are fanned out around the center circle.

Erase the circle and petal guidelines.

A Simple Daisy

1. Add a dark layer of tone to the center.

2. Reshape the petals to be more organic, if desired.

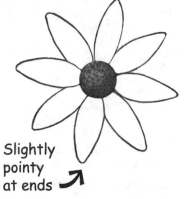

Slightly pointy at ends ↗

3. Add a light layer of tone to each petal.

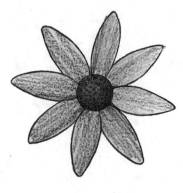

4. Darken the petal areas that are closest to the center.

5. Blend the tones on each petal to smooth them.

6. Draw thin, light lines down the length of each petal.

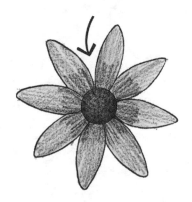

7. Darken the petal tips. Use an eraser to highlight some areas on the petals. Add a stem and shade it darker on one side.

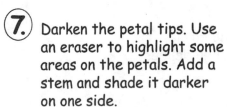

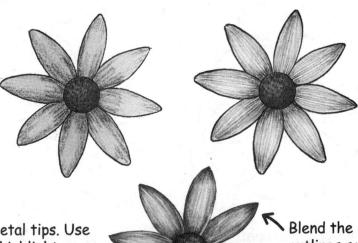

Blend the outlines so they are no longer visible

Tips are darker

GERBERA DAISY

KNOW:
• Simple shapes combined together can create more complex objects
• Steps to create a detailed Gerbera Daisy
• Layers, Overlapping, Repetition

UNDERSTAND:
• Connecting simple shapes is the first step to creating a recognizable, complex form.
• How to create the illusion of layers so that parts of a drawing appear to be in front of or behind other parts.

DO:
• Follow the steps provided to create an original Gerbera Daisy design.
• Be sure to follow the angles of each petal to indicate direction.
• Petals should be layered on top of one another for the illusion of 3D.
• The drawing will indicate which parts appear to be on "top" and which parts appear to be underneath using overlapping and size differences.
• Shade as desired.

VOCABULARY:

Balance - A principle of design, balance refers to the way the elements of art are arranged to create a feeling of stability in a work; a pleasing or harmonious arrangement or proportion of parts or areas in a design or composition.

Layer – To place one thing on top of another; top layers will obscure bottom layers.

Overlap - When one thing lies over and partly covers something else.

Perspective – The technique used to create the illusion of 3D onto a 2D surface. Perspective helps to create a sense of depth or receding space.

Shading - Showing change from light to dark or dark to light in a picture by darkening areas that would be shadowed and leaving other areas light. Shading is often used to produce illusions of dimension and depth.

Gerbera Daisy

Viewed from the side

1. Draw a small oval for the center of the flower (the eye).

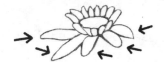

2. Next, add a row of small petals (florets) that curve around the top.

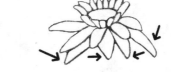

3. Add petals around the base. Notice the placement and direction.

4. Draw a few longer petals under the shorter ones. They should be slightly different lengths.

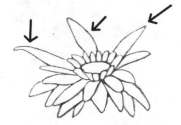

5. Next, add a layer of longer petals "under" those.

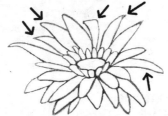

6. Draw a few smaller petals "under" the ones drawn in step 5 and a few at the sides.

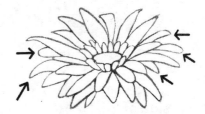

7. Add 3 long petals as shown.

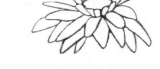

8. Add more petals around and underneath.

9. Add even more . . .

Finish by filling in the empty spaces with petals.

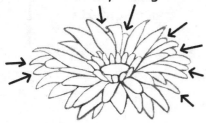

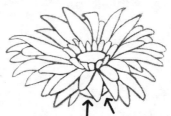

Add the stem base here

Go to the next page for shading details

Gerbera Daisy

Shading

① .

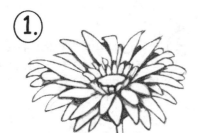

Add tone to the petals that appear to be "underneath."

← Add a skinny stem

② .

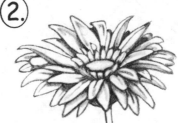

Add some lines down the centers of some petals and around the edges of others.

③ . Fill in the eye.

Try shading using scumbling inside of the eye.

close up of Scumbling

④ .

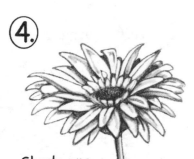

Shade one side of the stem to indicate a light source.

⑤ .

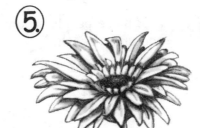

Continue shading. The closer the petals are to the eye, the darker they should be.

⑥ .

Deepen the shades to create contrast. Erase any areas that need to be highlighted.

HORSE

KNOW:

Contour, Curve, Geometric Shapes, Overlap, Replicate

UNDERSTAND:

• How to create an effective likeness of an animal using simple shapes.

• Simple shapes combined together can create more complex objects.

DO:

Create a contour drawing of a horse using geometric shapes, curves, and lines. Note the distance between shapes, the height of each shape, and whether or not they overlap one another.

NOTES:

• This tutorial shows how to create an outline of a standing horse. The same basic geometric shapes can be used for a horse in motion.

• Draw lightly so that the guidelines can easily be erased. All areas marked with dashed lines are the spots to erase.

VOCABULARY:

Contour – The outline and other visible edges of a figure or object. A contour drawing uses contour lines to represent subject matter.

Curve – A line or edge that deviates from straightness in a smooth, continuous way or, something that has the shape of a curve, such as an arc.

Geometric Shape – Any shape or form having more mathematic than organic design. Geometric designs are typically made with straight lines or shapes from geometry.

Overlap – When one thing lies over, partly covering something else. Depicting this is one of the most important means of conveying an illusion of depth.

Replicate – To make a close copy of something; a replica.

Horse

1. Start with an oval on the left for the chest and a circular shape on the right for the rear. Leave a bit of space as shown.

2. Add two circles for the head and chin above and to the left of the chest.

higher

lower

3. Connect all of the circles as shown.

face

neck

Connect chest & rear with two slightly curved lines

face

neck

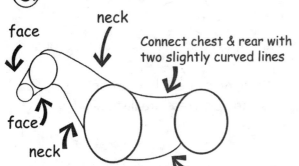

4. Erase areas indicated with dashed lines to form the contour of the horses body.

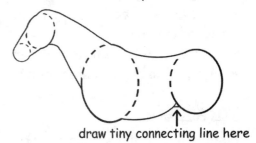

draw tiny connecting line here

5. Draw guidelines for legs. Draw an oval for each knee and ankle. Add hoof shapes at the ends.

Pay attention to which shapes overlap & which ones are higher or lower

hoof detail: triangle tip with a curved base

6. Connect the leg joints to the body with curved lines as shown.

add ear shape

Erase original leg guidelines

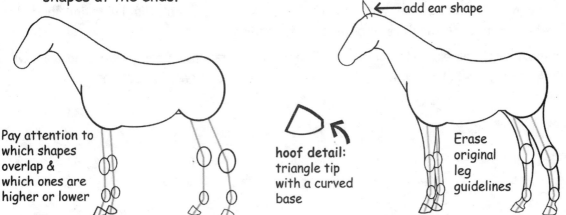

SHADED HORSE

KNOW:
Blend, Contrast, Highlight, Value Scale

UNDERSTAND: Shading adds depth, contrast, character, and even movement to drawings by capturing the shadows and highlights of an object.

DO: Create a line drawing of your subject using geometric shapes, curves and lines. Next, details will be added using shading and value scale.

NOTES:
- Observe the object that is being shaded and start by lightly adding tone to areas of darkness or shadow.
- Fill in the mid-tones next, taking care to keep the lightest areas untouched.
- Gently blend the light areas into the darker areas to help create realistic shading.

VOCABULARY:

Blend – To mix marks or colors smoothly together on a surface. This is sometimes called feathering.

Contrast – A large difference between two things; for example, dark and light.

Highlight – The area on any surface which reflects the most light. Highlights and shadows are important to the achievement of realistic shading.

Value Scale – Values are the lights and darks of your drawing. A complete value scale will range from white all the way to black with many shades of gray in between.

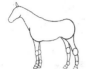

See previous page for horse outline drawing

shade using value scale

1. Add face details and erase dotted areas as shown below.

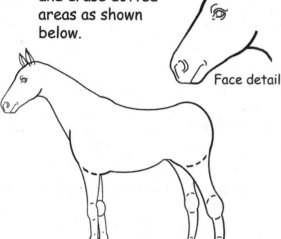

Face detail

2. Lightly sketch the mane, tail and muscle areas. The muscle striations are indicated by thin, shaded areas.

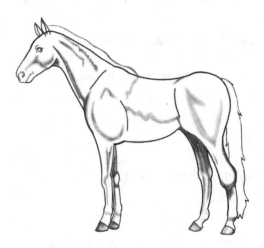

3. Add more shading to the underside of the horse. The upper area is usually lighter because of the light shining from above. Darken the tail as well.

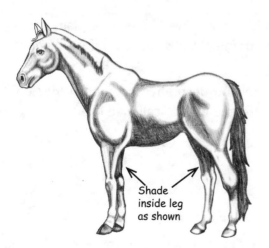

Shade inside leg as shown

4. Finalize the shading by deepening tones in the shadow areas and erasing areas of highlight.

Blend as desired.

Notice highlights in mane, tail, rear, face and other rounder parts of the horse's body

SEAHORSE LINE ART

KNOW:

Contour, Curve, Geometric Shapes, Line, Scalloped Edge

UNDERSTAND:

• How to create an effective design using simple shapes.

• Simple shapes combined can create more complex objects.

• Drawing in a light, sketchy manner makes objects easier to change or erase if needed.

DO:

Create a line drawing using geometric shapes, curves, and scalloped edges to create an original seahorse creature.

VOCABULARY:

Contour – The outline and other visible edges of a figure or object. A contour drawing uses contour lines to represent subject matter.

Curve – A line or edge that deviates from straightness in a smooth, continuous way or, something that has the shape of a curve, such as an arc.

Geometric Shape – A non-organic shape that utilizes rectilinear or simple curvilinear motifs or outlines in design.

Line Art – An image that consists of distinct straight and curved lines on a plain background without gradations in shade or color. The outline of the seahorse before shading is line art.

Scalloped Edge – A series of similar curves that form a decorative edge or border on something. The spines on the seahorse's back are created with a scalloped line.

Seahorses are a type of fish named for their equine (horse-like) appearance

 Seahorse

1. Start with 3 circles.

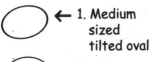 ← 1. Medium sized tilted oval

← 2. Larger oval-circle shape

○ ← 3. Small circle off to the side

2. Draw connecting lines as shown below.

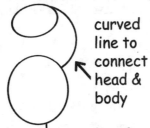

curved line to connect head & body

line for tail

3. Draw front of neck, front of tail & curve at small circle.

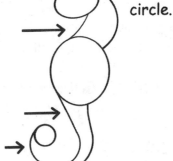

4. Connect tail and add snout.

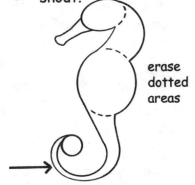

erase dotted areas

5. Add small circle in tail.

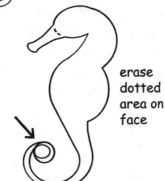

erase dotted area on face

6. Erase tiny line to form the tip of the tail.

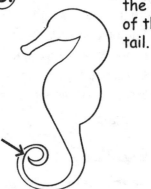

7. Add an eye and draw a back fin.

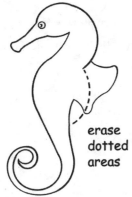

erase dotted areas

8. Draw tiny triangles along the head and back.

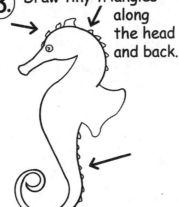

9. Draw a rectanglular pattern on the body.

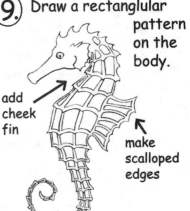

add cheek fin

make scalloped edges

71

SEAHORSE WITH SHADING

KNOW:
Blend, Contrast, Scalloped Edge, Value Scale

UNDERSTAND: By adding shading to a drawing, an artist can create the appearance of light and shadow and make an object or scene appear more realistic and visually appealing.

DO: Using a line drawing of the seahorse, add value to create the illusion of depth to make the drawing appear three-dimensional.

NOTES:
- Begin with a simple line drawing, add detail, then start the shading process.
- Shading adds depth, contrast, character, and movement to an artwork by capturing the shadows and highlights of an object or scene.
- Darken gradually, each time laying a thin layer of shade.
- Strong contrasts between light and dark in an artwork indicate bright highlights and deep shadows.

VOCABULARY:

Blend – To mix marks or colors smoothly together on a surface. This is sometimes called feathering.

Contrast – A large difference between two things; for example, hot and cold, green and red, light and shadow.

Value Scale – Values are the lights and darks of your drawing. A complete value scale will range from white all the way to black with many shades of gray in between.

Seahorse with Shading

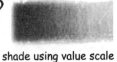
shade using value scale

1. Finish drawing all outline details including snout, eye & fin lines.

eyebrow →
bag under eye →
snout →
curves
cheek
curves

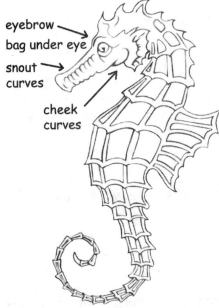

2. Lightly shade the tops of each curved rectangular shape, the snout and under the eye as seen below.

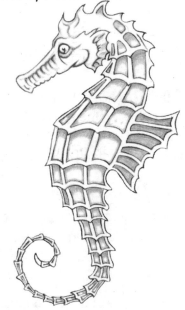

3. Fill in the remainder of each rectangle lightly. Darken areas near the tops of the rectangles.

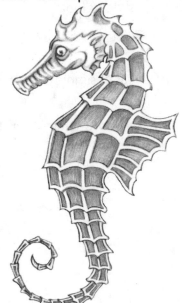

4. Continue to darken certain areas to create an appealing contrast. Erase lightest areas for crisp highlights.

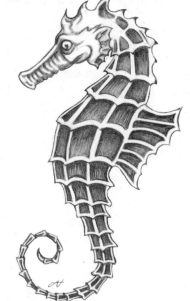

DANDELION

KNOW:

Balance, Layering, Geometric Shapes, Rotational Balance

UNDERSTAND:

- How to arrange elements in an artwork so that they appear symmetrical or equally balanced
- How to create an effective design using simple shapes and lines.

DO: Follow the steps provided to create an original dandelion drawing using the techniques provided, which concentrate on overlapping and rotational balance. Add "extras" like florets blowing away in the wind.

VOCABULARY:

Balance – A principle of design, balance refers to the way the elements of art are arranged to create a feeling of stability in a work; a pleasing or harmonious arrangement or proportion of parts or areas in a design or composition.

Blending – To mix smoothly in order to obtain a particular style or look.

Floret – A small flower or one of the closely clustered small flowers that make up the flower head of a composite flower.

Geometric Shape – A non-organic shape that utilizes rectilinear or simple curvilinear motifs or outlines in design.

Radial or Rotational Balance – Any type of balance based on a circle with its design extending from or focused upon its center.

Dandelion

1. Start with a wide oval. This will be the outer flower guideline. Add a smaller oval inside.

2. Connect a floret and seed as seen below to the center oval. This can be drawn as curved lines on a straight line.

3. Continue to draw the florets around the center oval using a rotational symmetry pattern.

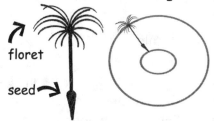

floret

seed

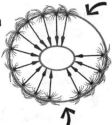

Leave an empty area near top and bottom

4. Draw a triangular shaped base attached to the center oval with a long, thin stem.

5. Lightly shade the center oval and stem. Add another floret as shown (see arrow).

6. Continue to draw a pattern of short florets all around the center.

Start a second row of short florets under the first

7. Finally, add a 3rd row of florets to fill the space.

Erase

Detail of the 3 floret rows

8. Lightly smudge with a tissue or your finger to blend tones for a "fuzzy" look.

9. Draw a few random florets blowing in the wind.

A dandelion flower head is composed of hundreds of smaller florets (top) & seed heads (bottom)

SHADING WITH STIPPLING

KNOW:

Highlight, Pointillism, Stippling, Value Scale

UNDERSTAND: Stippling is a technique used to create images, light, and shadow by making many small dots on a piece of paper that come together and appear as a blended form when viewed from a distance. This is a technique used by artists when shading with pen and ink, which does not allow blending.

DO: Explore the process of stippling and how it can create the illusion of value in an artwork. Create a basic line drawing focusing only on the shape of an item, then implement shading techniques using a series of dots known as stippling.

NOTES:

- Dots closer together have a darker value, while dots spread further apart offer a lighter value.

- When first practicing stipple techniques, have a photo or an object to look at as opposed to drawing from imagination. It is much easier to examine shadows and light as you draw by actually observing an object.

- Observe the light source. Light will determine what areas need more stippling and what areas need less.

- An image with lots of dark values will need more stippling than an image with plenty of light. This means that the high-density dots will require more time to recreate an image.

- Make dots, not dashes. Stipple carefully and always lift your pen completely off the paper before setting it back down.

- Try to keep all the dots evenly spaced.

- You do not have to stipple as directed in the tutorial: some artists cover their objects with widely-spaced dots first and then go back and add dark areas where needed. There is no right or wrong way to do it.

- Don't rush! Stippling can be time consuming. Step back and look at the drawing frequently from a distance. The dots should eventually look like a smooth, shaded image rather than just dots.

- When you feel comfortable, try drawing a color artwork using a form of stippling called "pointillism". Pointillism is a form of art made famous by the French artist George Seurat where dots of color are applied next to each other so that they appear to be blended together from a distance (visual mixing). For example: blue dots of paint or marker spread among yellow dots will appear green from a distance.

VOCABULARY:

Highlight – The area on any surface which reflects the most light. Highlights and shadows are important to the achievement of realistic shading.

Pointillism – A method of painting developed in France in the 1880s in which tiny dots of color are applied to a canvas. When viewed from a distance, the points of color appear to blend together to make other colors and to form shapes and out-lines.

Stippling – A drawing, painting or engraving method employing dots to make up an image rather than lines. These many dots are laid carefully side by side to indicate light and shadow. With this technique there is no line work since everything is comprised of dots.

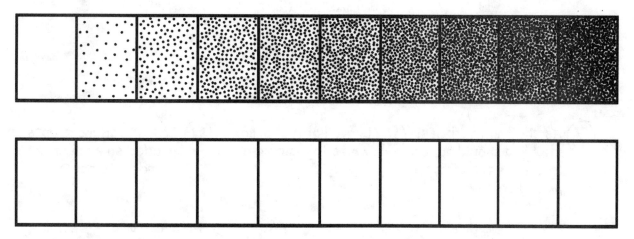

Value Scale - Values are the lights and darks of your drawing. A complete value scale will range from white all the way to black with many shades of gray in between.

Stippling, a.k.a. pointillism, is a type of drawing that involves creating shapes & images via many small dots.

Shading with Stipple

1. Begin by sketching an outline of a simple image in PENCIL.

A fine pen works best for this type of shading. Use a pencil first to get the basic object outline. Start with pen at step 3.

2. It is helpful to outline the shapes of shadows seen on the object.

The lines seen on the pear at right indicate changes in shadow and tone. Draw these outlines lightly and in pencil as they will eventually be erased.

3. Begin stippling the darkest areas with a fine pen.

Carefully lift the pen and press it to to the paper. The closer the dots are placed, the darker the area appears.

4. Stipple the next darkest area. Space this round of dots slightly further apart from those made in step 3.

Move slowly to avoid making dash lines.

5. Start filling in lighter areas with further spaced dots.

From far away, these dots will begin to appear as blended shadows.

6. Continue stippling lighter areas with fewer dots. Erase pencil lines when ink is dry.

Stippling can take a very long time to complete, so don't rush your work.

7. As shading continues, stippling should appear lighter as the dots are placed further apart.

8. Leave lightest area white to indicate a highlight.

9. Lastly, add more dots as needed so each area blends into one another.

Look at your art from a distance. The dots should come together & look like a shaded image rather than just dots.

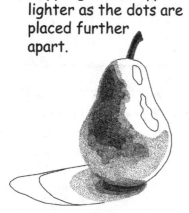

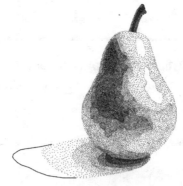

The smaller the mark that is made, the more realistic the image will look. Fine point pens are a great choice for this style of shading.

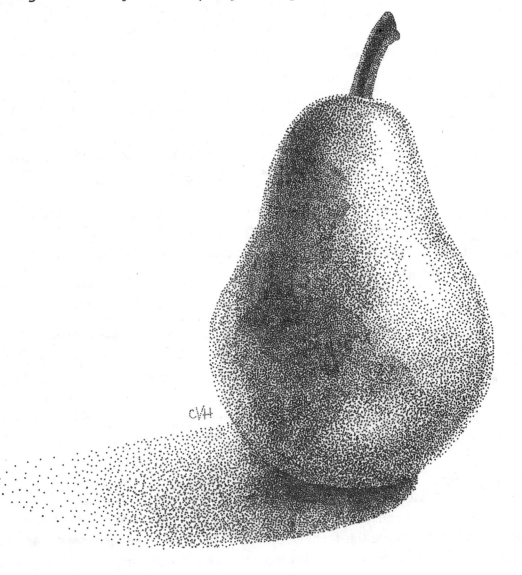

Once your stippling is complete, make sure the ink is dry before you erase the original pencil guidelines.

TONAL VALUE PORTRAIT

KNOW:
Hatching and Cross-Hatching, Line

UNDERSTAND:
- Techniques used by draftsmen, engravers, and other artists to shade when using mediums that do not allow blending.
- Hatching and cross-hatching is a method of line drawing that describes light and shadow. The representation of light utilizes the white or openness of the page, while shadow is created by a density of crossed lines.
- The density and movement of lines indicate form by showing light and shadow.

DO:
Practice hatching and cross-hatching by creating a value scale; create a Tonal Value Portrait using learned techniques.

TIPS:
- Get a large photo or enlarge one on a photo copier so that is fills up a piece of paper (8.5" x 11"). Black and white works best. Even better: take the photo and "posterize" it using graphics software on a computer so the individual shades are easier to see.

- Take your time when outlining the features and again when numbering the shades. It may be a little time consuming; however, the extra time you take now will take the guess work out of choosing what shade goes where.

VOCABULARY:
Hatching and Cross-Hatching — Creating tonal or shading effects with closely spaced parallel lines. When additional lines are placed at an angle across the first, it is called cross-hatching. Artists use this technique, varying the length, angle, closeness and other qualities of the line when shading a drawing. Hatching is also referred to with the French word "hachure."

Line - A mark with length and direction; an element of art which refers to the continuous mark made on some surface by a moving point.

The value scale below shows you can see how the light end on the right uses parallel lines spaced widely apart to represent light. The dark end on the left layers lines that criss-cross to create a feeling of darkness or shadow.

Hatching Value Scale

Cross-Hatching Value Scale

Practice shading using
Hatching and Cross Hatching
Value Scale
Create examples of each in the spaces provided

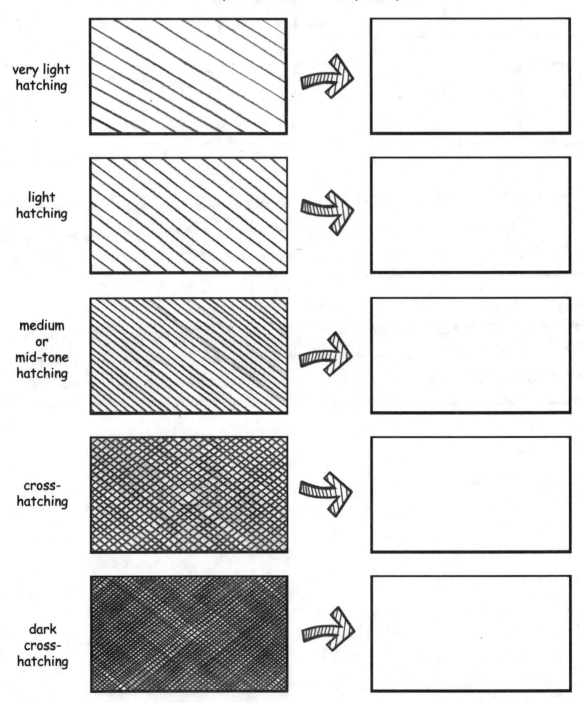

very light
hatching

light
hatching

medium
or
mid-tone
hatching

cross-
hatching

dark
cross-
hatching

TIP: If you can, "posterize" the photo using computer software. It breaks down the shades for you!

Tonal Value Portrait

using hatching and cross-hatching

1. Find a big, close-up photo of a face (or take one of yourself!) Make it black & white on photocopier.

2. Use charcoal or pencil to cover the BACK of photo. This is one way to transfer an outline of the photo to another paper.

3. Tape the photo to a different piece of paper (charcoal side DOWN). Use a pen or pencil to outline the major details.

↙ Take your time!

4. Gently separate the photo from the paper. The transfer drawing should look something like this.

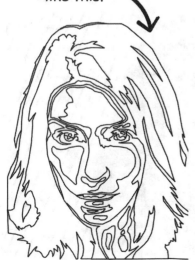

5. Tape a clean piece of paper to the back of the PHOTO so your hands won't get dirty. Number the different shades directly on the PHOTO (not the drawing). Try to find a total of five different shades of gray.

Number everything that is white with a number 1.

Light Gray = 2

Gray = 3

Dark Gray = 4

Black = 5

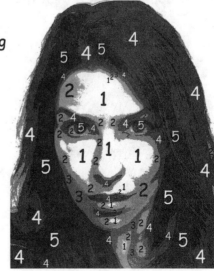

Tonal Value Portrait

using hatching and cross-hatching

6. Start shading. Use hatch lines that are far apart from each other to create shade on the lightest areas.

7. Next, shade with hatching to indicate the hues marked with a "2" on the photo.

8. For all of the areas marked with a "3", draw tightly spaced hatch marks.

Any angle is fine!

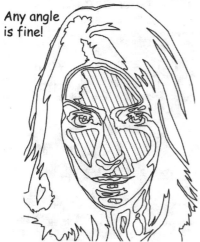

These are areas marked "1".

These lines should be closer together than the ones in step 6.

These lines should be closer than the ones drawn in step 7.

9. Use cross-hatching on areas marked with "4". All of the "4's" should appear darker than the "3's".

10. Finally, fill in the areas marked "5" with tightly spaced cross-hatching. These marks should appear darker than the ones made in step 9. Add a few hatch marks to indicate a background.

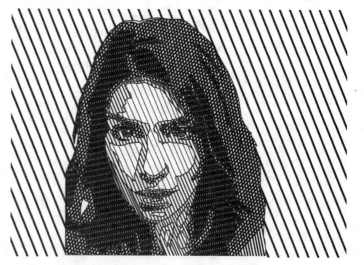

Tonal Value Portrait

using hatching and cross-hatching

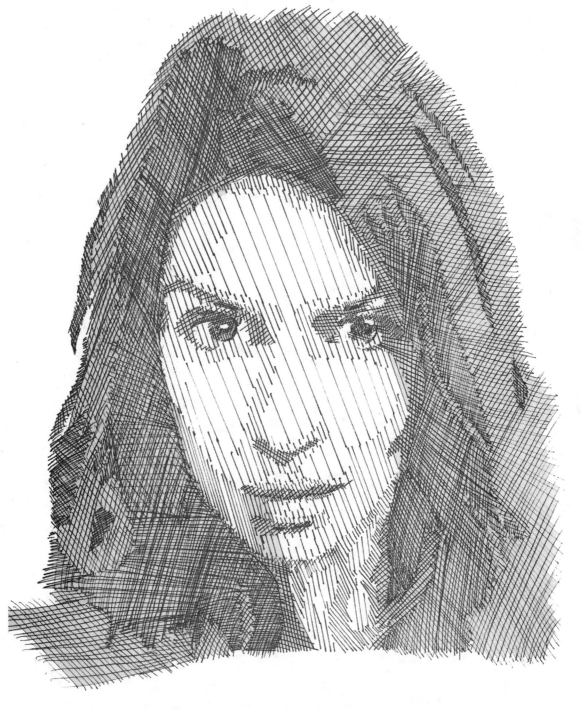

Chapter 3

Texture & Pattern

TEXTURE AND PATTERN

Texture and pattern are two elements and principles of art that help add a sense of physicality to an artwork by creating an illusion of three-dimensional surfaces and shapes. This makes an artwork more realistic, immersive, and engaging.

Texture shows the surface quality or "feel" of an object; its smoothness, roughness, softness, etc. **Pattern** is the repetition of shapes, lines, or colors.

What's the difference?

TEXTURE is the way something feels. In a drawing, texture is the way something *looks* like it feels.

Furry Texture Sandy Texture Cracked Texture

Textures are structures with irregular surface activity using lines and marks that are arranged randomly or without a specific pattern. Textures on objects are physical things that can be touched and felt. Textures can be smooth, rough, hard, soft, etc. In a drawing, that physical touch cannot be created, however, the perception of a physical quality can be created using *implied* texture. This visual texture is made by the artist through the use of line, shading, and color.

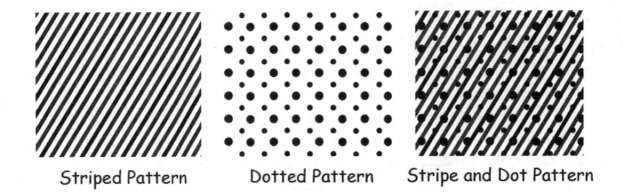

Striped Pattern Dotted Pattern Stripe and Dot Pattern

Patterns are shapes or objects that are repeated over and over again, usually structures with geometric or symmetrical qualities. Any kind of pattern in art refers to a theme or recurring visual event. Visual patterns are everywhere in both art and nature.

There are millions of textures and patterns that exist. Below is a small list of patterns and textures.

PATTERN IDEAS: Spirals, waves, bubbles, cracks, spots, stripes, curves, zig-zag, scales, checkerboard, floral, gingham, paisley, tweed, plaid, symmetrical or asymmetrical, barcode, basket weave, splatter, camouflage, rope, wood grain, lace, ombre, stipple, ripple, etc.

TEXTURE IDEAS: Flat, smooth, shiny, glossy, glittery, velvety, feathery, soft, wet, gooey, furry, sandy, leathery, crackled, prickly, abrasive, rough, furry, bumpy, corrugated, puffy, rusty, slimy, woven, woolen, flaky, etc.

TEXTURES and **PATTERNS** can be seen separately or can be combined together in one artwork. Below are two samples of both texture and pattern used together.

 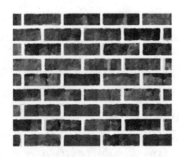

Tiger Stripe Pattern with Fur Texture Rectangle Pattern with Brick Texture

The following exercises explore pattern and texture in design. Start with the simple warm-up of using a tracing of your hand to create a template to draw inside of. One lesson requires the repetition of a shape or object using a different pattern inside each finger. Another asks for the appearance of different surface qualities (textures) inside each finger. Have fun with this and don't be afraid to try out new patterns and textures that aren't listed or drawn here.

Extension – Don't want to use a hand? Try drawing seasonal objects such as pumpkins in autumn or flowers with petals that have separate sections. Add a different texture or pattern to each segment for the same practice.

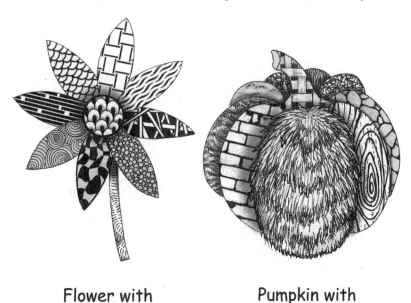

Flower with
Patterns

Pumpkin with
Textures

FINGER PATTERNS

KNOW:
Pattern, Repetition

UNDERSTAND:
The elements of a pattern repeat in a predictable manner.

DO:
Practice creating the repetition of a design by tracing or drawing a hand and then drawing a pattern inside each finger.

NOTE: For best results, hold the pencil at a 90-degree angle when tracing the hand. This helps to create a realistic outline.
There are millions of patterns to create – this worksheet shows only a few. Try creating your own original patterns for a unique artwork!

EXTRA CREDIT: Add a different pattern on the palm of the hand and another at the base of the hand on the "ground".

PATTERN IDEAS: Spirals, waves, bubbles, cracks, spots, stripes, curves, zig-zag, scales, checkerboard, floral, gingham, paisley, tweed, plaid, symmetrical or asymmetrical, bar-code, basket weave, splatter, camouflage, rope, wood grain, lace, ombre, stipple, ripple, etc.

VOCABULARY:

Non Representational Art – Another way to refer to Abstract Art. These artworks do not resemble, depict, or portray any object or a thing in the natural world.

Pattern – The repetition of shapes, lines or colors.

Positive Space – Space in an artwork that is filled with something, such as lines, designs, color, or shapes.

Repetition – A way of combining elements of art so that the same elements are used over and over again.

Finger Patterns

A pattern is the repetition of shape, line or color
Practice creating patterns by filling each finger with a different design

Start by tracing your hand.
TIP: For best results, keep the pencil at a 90° angle.

There are millions of patterns you can create, these are just a few! Try copying the patterns shown or invent your own.

Scales

Dots

Circles and Lines

Overlap Weave

Stripes

"Wrap" the patterns around each finger for a 3D effect.

This checkerboard pattern appears 3D because it is "wrapped" around the wrist.

Look at your hand and draw the lines that you see to add detail.

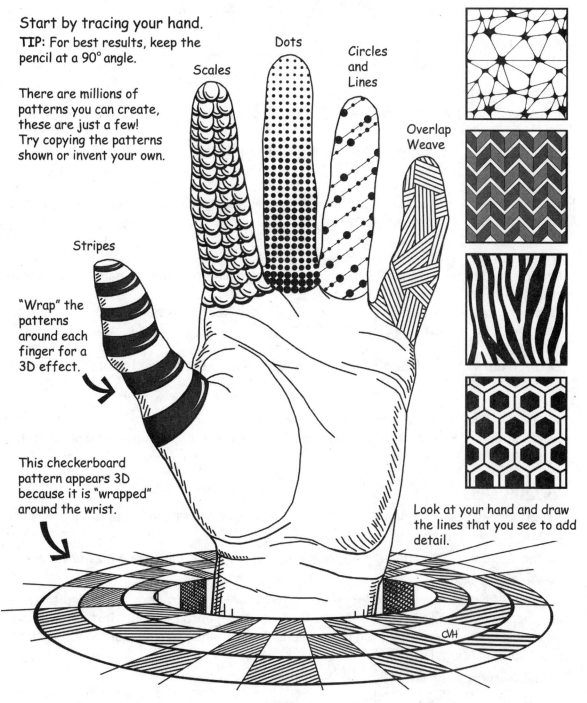

CVH

FINGER TEXTURES

KNOW:
Repetition, Texture

UNDERSTAND:
- The techniques an artist uses to show how something might feel or what it is made of in an artwork.
- How to create the appearance of surface characteristics in an object.

DO:
Practice creating the illusion of tactile surface quality by tracing your hand and then filling each finger with a different texture.

NOTE:
For best results, hold the pencil at a 90-degree angle when tracing the hand. This helps to create a realistic outline.
There are millions of textures that exist – this worksheet shows only a few. Try creating your own textures for a unique artwork!

EXTRA CREDIT: Add another texture on the palm of the hand and at the base of the hand on the "ground".

TEXTURE IDEAS: Flat, smooth, shiny, glossy, glittery, velvety, feathery, soft, wet, gooey, furry, sandy, leathery, crackled, prickly, abrasive, rough, furry, bumpy, corrugated, puffy, rusty, slimy, woven, woolen, flaky, etc.

VOCABULARY:

Repetition – A way of combining elements of art so that the same elements are used over and over again.

Tactile Textures – The immediate tangible feel of a surface (also known as physical texture).

Texture – The way something looks like it might *feel* in an artwork. Simulated textures are suggested by an artist with different brushstrokes, pencil lines, etc. Texture describes either the way a three-dimensional work actually feels when touched, or the visual "feel" of a two-dimensional work

Visual Textures – The visual impression that textures produce.

Finger Textures

Texture is the surface quality or "feel" of an object. In art, texture is the way something looks like it might feel. Simulated textures are suggested by an artist with different brushstrokes, pencil lines, etc.

Practice creating the illusion of physical texture by filling each finger with a different "feel."

Wooden Texture can be drawn as a bunch of long, curved lines going in the same direction with a knot here and there.

Hairy Texture created using layers of lines.

Wart Texture is made by drawing randomly spaced/sized bubbles.

Sand Texture created using a series of random dots.

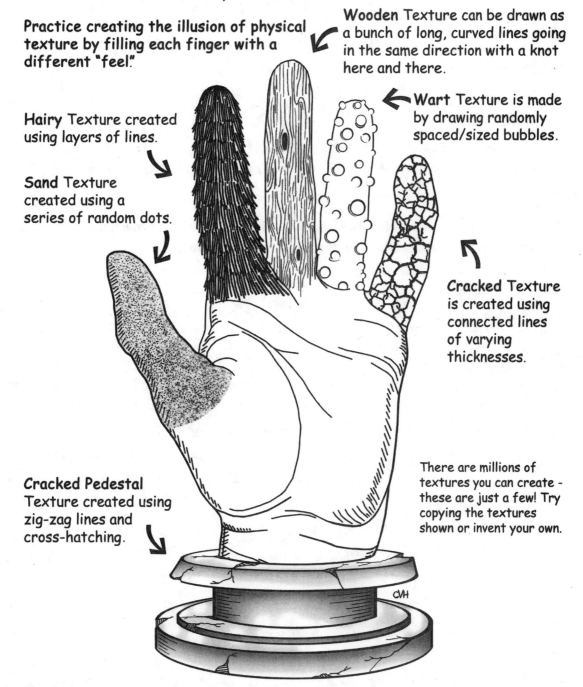

Cracked Texture is created using connected lines of varying thicknesses.

Cracked Pedestal Texture created using zig-zag lines and cross-hatching.

There are millions of textures you can create - these are just a few! Try copying the textures shown or invent your own.

BRICK WALL

KNOW:

Parallel Lines, Pattern, Rectangle, Stagger

UNDERSTAND:

• The elements of a pattern repeat in a predictable manner.
• How to create the appearance of a brick wall by using staggering and pattern.

DO:

• Create a realistic pattern of a brick wall using the tips and tricks provided.
• Shade if desired (darker bricks/lighter areas between bricks).

VOCABULARY:

Parallel Lines – Two or more straight lines or edges on the same plane that do not intersect. Parallel lines have the same direction.

Pattern – The repetition of any thing including shapes, lines, or colors.

Rectangle – A four-sided shape that is made up of two pairs of parallel lines and that has four right angles. The shape has one pair of lines that is longer than the other pair.

Stagger – To arrange shapes in a series of different positions.

Brick Wall

Building bricks are usually staggered or offset for support

Simple Wall

1. Use a ruler to draw a thin line at the top of the paper.

2. Continue to fill paper with equally spaced lines.

row 1	
row 2	
row 3	
row 4	
row 5	

3. Draw a line in the upper left corner of row 1. Repeat for all odd numbered rows (1,3,5,7, etc.)

4. Draw evenly spaced lines to form a row of rectangles until each odd numbered row is filled.

5. Draw rectangles on row 2. Start the first one below the center of the 1st brick in row 1.

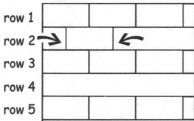

6. Continue to draw rectangles using the same placement on all of the even numbered rows (2,4,6,8,10,12, etc.).

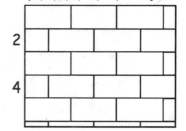

Detailed Wall

1. Follow step one above, leave a small space then draw another line. Continue to fill the paper this way.

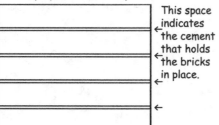

This space indicates the cement that holds the bricks in place.

2. Fill with rectangles as seen in the steps above. Add a small space between each one as shown below.

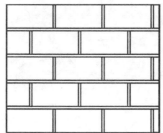

3. Erase connecting lines between each brick. Shade bricks dark and the area between the bricks light.

97

Brick Wall

Shading

1.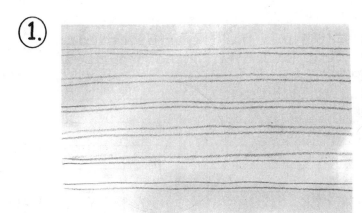

Start with a horizontal line at the top of the paper. Leave a small space then draw another line. Continue to fill the paper with this pattern.

2.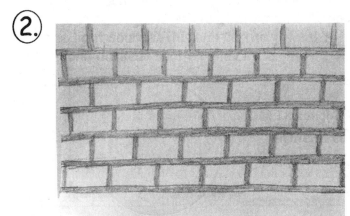

Fill in the vertical lines with a light layer of tone between rows to form rectangular shapes. Fill in the horizontal rows as well.

3.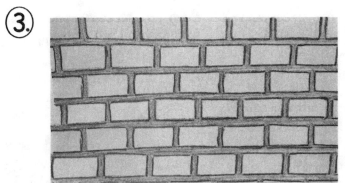

Outline each brick to make it stand out more.

Brick Wall

Shading 2

 4.

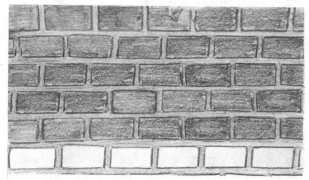

Fill in the bricks with a medium layer of tone.

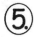 **5.**

Gently blend tones to smooth them.

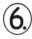 **6.**

Add some distressing to bricks by using different pencil pressures and random crack lines. Use a kneaded eraser on the edges and centers of some bricks for highlights.

CRACKS AND CLIFFS

KNOW:
Asymmetry, Depth, Pattern, Repetition, Texture

UNDERSTAND:
- The techniques an artist uses to show how something might feel or what it is made of in an artwork.
- How to create the appearance of surface characteristics in an object.
- The "Y" Trick (cracks look like the letter Y).

DO:
- Practice creating the illusion of tactile surface quality.
- Follow the examples shown to create the illusion of surface cracks and edges of cliffs.
- Create the illusion of cracks using the "Y" technique.

NOTE:
- Every crack is unique – no two are exactly alike. Cracks are usually asymmetrical.
- Drawings of cliffs should indicate towering height and depth. To help define the scale of a cliff, add objects beneath it such as trees or a river to show the cliff's size in relation to these other (smaller) natural formations.

VOCABULARY:

Asymmetry – Not identical on both sides of a central line; not symmetrical.

Depth – The third dimension; the apparent distance from front to back or near to far in an artwork.

Pattern – The repetition of shapes, lines or colors.

Repetition – A way of combining elements of art so that the same elements are used over and over again.

Texture – The way something looks like it might *feel* in an artwork.

Visual Textures – The visual impression that textures produce.

Cracks and Cliffs

Draw a Crack Using the "Y" Trick

1. Start with a letter "Y" shape.

This should be drawn with shaky lines, not straight.

2. Add two letter "V's" to the tops of the "Y" shape as shown.

The "V" should be smaller than the "Y" opening.

3. Add four more "V's" to the top of the "V's" drawn in step 2.

Keep adding "V's" until your drawing looks like a cracked surface.

Drawing Cracks on Objects

Start with an outlined object.

Add a "V" shape on one edge.

Add a "Y" shape to that.

Add a small crack on opposite side

Take a chunk out.

Shade as desired.

Draw a Cliff

Start with the top of the cliff. Draw lots of jagged edges at the base.

Draw curved vertical lines from each edge.

Add more verticals coming from jagged edges as shown.

Draw things below cliff to show depth.

Hole in the Ground
using the "Y" trick, hatching and cross-hatching.

CVH

WEAVING DESIGN

KNOW:
Overlap, Pattern, Repetition, Texture, Weave

UNDERSTAND:
- Weaving is one of the most ancient forms of human creativity. Baskets and textiles would not have been possible without weaving.
- The simple over-under sequence that creates the illusion of a weaving within a drawing.
- The elements of a pattern repeat in a predictable manner.

DO: Practice creating the illusion of woven fabric by layering/overlapping thickened lines (ribbons) in the over-under sequence demonstrated in the tutorial. Use any length of ribbons with a minimum of five vertical and five horizontal ribbons in the design.

NOTE: For best results, don't use a ruler! Uneven edges and jagged lines look more authentic than straight, perfect lines in a weaving.

VOCABULARY:

Overlap – When one thing lies over, partly covering something else. Depicting this is one of the most important means of conveying an illusion of depth.

Repetition – A way of combining elements of art so that the same elements are used over and over again.

Pattern – The repetition of shapes, lines or colors.

Texture – The way something looks like it might *feel* in an artwork.

Weaving – The interlacing of long, thin materials, such as yarn or thread to make cloth (fabric) or baskets.

This tutorial can be used to draw the likeness of woven material or as a template to actually weave something!

Weaving

NO ruler necessary

(actually, it looks better if the lines are hand-drawn and a bit crooked)

1. Draw a vertical ribbon and a horizontal ribbon overlapping as shown.

top ribbon is "over"
bottom ribbon is "under"

2. Add all of the horizontal ribbons.

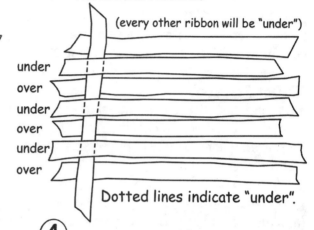

(every other ribbon will be "under")

under
over
under
over
under
over

Dotted lines indicate "under".

3. Add another vertical ribbon.

Dotted indicates "under".

4. Add another vertical.

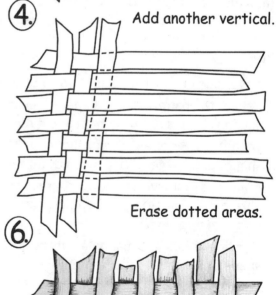

Erase dotted areas.

5. Keep adding verticals.

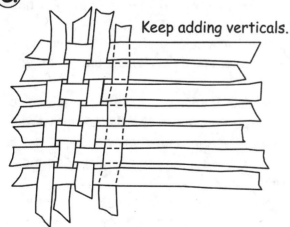

6.

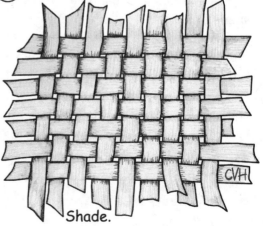

Shade.

CVH

MANDALAS

KNOW:
Elements and Principles of Design, Mandala, Radial and Symmetrical Balance, Radius, Circumference, Diameter, Compass, Template, Culture/Tradition

UNDERSTAND:
- Cultural, historical and personal use of mandalas.
- Circles are sacred symbols in some cultures.
- Art is done for a variety of purposes including ceremony, ritual, healing, meditation, joy, and expression.

DO: Create an original mandala showing radial or symmetrical balance while including (and identifying) at least two elements of art, two principles of design, and at least three sections of an original pattern that radiate from the center of the work.

TIPS:
- Any shape or design can be used to create a mandala.
- Repeat the pattern. Each shape or design drawn in one section must be repeated in all sections. This is a key element in creating mandalas. Color must also be the same.
- Try not to over-analyze what shapes will be a part of the mandala. Select color and draw shapes and images based on what makes you feel good or what inspires you.
- Mandalas can have geometric shapes, organic forms or recognizable images. To personalize a mandala and add significance for the person creating it, add images that have personal meaning.
- Drawing/coloring a mandala can be a highly enriching experience in which you find shapes, colors and patterns to represent anything meaningful. Mandalas are great tools for meditation and increasing self-awareness. Work in a quiet space (or with meditative music) and focus on every line drawn and every color laid down for the ultimate meditative experience.
- The best thing about designing your own mandala is that you have the freedom to choose whatever shapes and colors you feel express your sense of self and your view of reality. This will help you to create a mandala drawing that is uniquely you.
- As more designs are added, the mandala will start to look more complex. Add more designs in empty spaces for a detailed artwork.
- As more designs are added, the mandala will start to look more complex.

VOCABULARY:

Balance – A principle of design, balance refers to the way the elements of art are arranged to create a feeling of stability in a work; a pleasing or harmonious arrangement or proportion of parts or areas in a design or composition.

Circumference – The distance around a circle.

Diameter – A straight line segment that passes through the center of the circle and whose endpoints lie on the circle. Half of the diameter is the radius.

Elements of Design – The basic components used by the artist when producing works of art. Those elements are color, value, line, shape, form, texture, and space. The elements of art are among the literal qualities found in any artwork.

Mandala – Sanskrit word that means "circle". A mandala is a complex abstract design that is usually circular in form. Mandalas generally have one identifiable center point, from which emanates an array of symbols, shapes, and forms.

Principles of Design – The ways that artists use the elements of art in a work of art; balance, emphasis, movement, pattern, repetition, proportion, rhythm, variety and unity.

Radial Balance – Design within a circle extending from or focused upon its center.

Repetition – Combining elements of art so that the same elements are used over and over again. Thus, a certain color or shape might be used several times in the same picture.

Rotational Symmetry – An object that looks the same after a certain amount of circular movement around that object's center.

Essential Questions:

How does art help us understand the lives of people of different times, places, and cultures? How does knowing the contexts, histories, and traditions of art forms help us to create works of art and design?

Notes:

- Mandalas have been used in Tibetan meditations, the rose windows of Gothic cathedrals, the Aztec calendar stone, and Navaho sand paintings. In the East, mandalas are used as a focusing device for meditation. Carl Jung used the mandala as an integrative and centering device in psychotherapy.
- A mandala is considered "A Sacred Circle." It is the focal point that symbolizes our spirit, which (like the circle) has no beginning or end. A circle represents wholeness or completion.
- Mandala art therapy & healing can be a great source of reflection on one's soul.
- Creating a mandala is not about a final product; it is about the journey of creation.

Draw steps 1-3 lightly so the lines are easier to erase later

Mandalas

Have a good eraser handy for this one!

1. Use a compass or find a large circle to trace. Fill up the paper with the circle.

2. For a Mandala using radial balance, divide the circle into equal "pizza slice" sections.

3. Next, add at least two more circles inside the outer circle to make more sections.

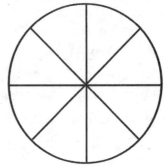
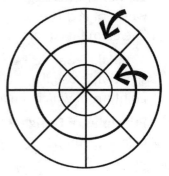

4. Begin the design. Draw an interesting shape in one of the innermost sections.

5. Repeat that same shape around the center circle. If it's not perfect, that's OK!

6. Add a border of your choosing around the shapes you just made to frame the design.

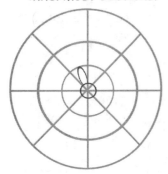
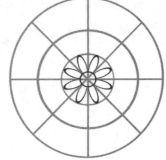
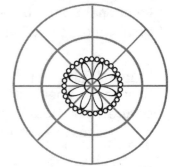

7. Repeat another design in the next section . . .

8. Add more patterns and fill with detail.

9. Erase the guidelines and color as desired.

106

These steps are only an example. Choose your OWN important items and symbols!

Mandalas
Personalized

1. List at least five items that are important to YOU. Next, try to draw a symbol to represent each of those things.

2. Draw a circle with guidelines and begin to add your symbols. Start in the center.

3. Repeat that symbol in all of the inside sections. Add more detail if desired.

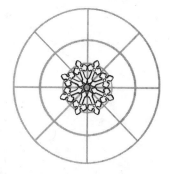

4. Add the next section of symbols all the way around.

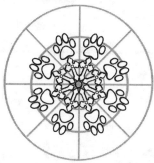

5. Fill in empty areas if desired with shapes or other symbols.

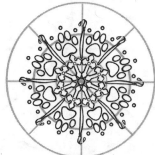

6. Add the next section of symbols . . .

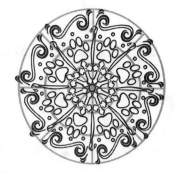

7. Keep adding symbols until the mandala looks full and very detailed.

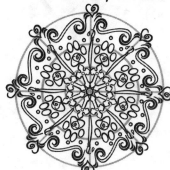

8. Erase the guidelines and add more details.

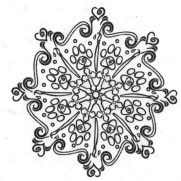

9. Color or shade as desired.

Lightly trace this Mandala template
on a separate piece of paper

109

NATURAL SPIDER WEB

KNOW:
Asymmetry, Radial Balance, Repetition, Starburst, Symmetry, Uneven

UNDERSTAND:
A spider web is based on a circle with its design extending from (or focused upon) its center. A web is often slightly uneven but still holds a repetitive pattern.

DO:
- Create an original natural spider web design based on radial balance using the tips and tricks provided.
- Add a spider and other "extras".

Start adding webbing around the center point with random, non-uniform lines.

Continue to add lines radiating around the center.

NOTES:
A spider web is a tool created by a spider out of proteinaceous spider silk extruded from its spinnerets. This can usually be seen as white in color. For a more realistic rendition, try this exercise using a white pencil, pastel, or chalk on black paper.

VOCABULARY:

Asymmetric – Not identical on both sides of a central line; not symmetrical.

Radial or Rotational Balance – Any type of balance based on a circle with its design extending from or focused upon its center.

Repetition – The act of repeating; to complete a specific action or performance again.

Starburst – A pattern of lines or rays radiating from a central point.

Symmetry / Symmetrical Balance - The parts of an image or object organized so that one side duplicates, or mirrors, the other.

Uneven – Irregular, varying or not uniform.

Natural Spider Web

① 1.

Start with a square shape. Draw an un-even starburst design inside.

② 2.

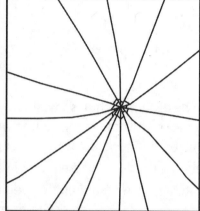

Near the center, draw lines across the starburst to create tiny, un-equal triangles (Looks like broken glass).

③ 3.

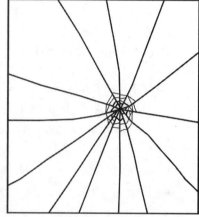

Continue to add more lines coming from the center. It looks more realistic if the lines are a bit uneven.

④ 4.

Keep adding layers of web radiating from the center.

⑤ 5.

Continue to add web lines, each layer further apart from the last.

⑥ 6.

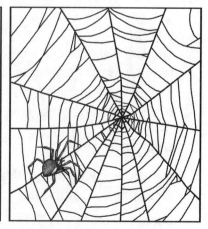

Finish the web using un-evenly spaced lines. Add a spider.

DREAMCATCHER

KNOW:
Cultural Significance, Dreamcatcher, Symmetry, Weave

UNDERSTAND:
- In Native American culture, the dreamcatcher is a well-known symbol that has deep-rooted meanings and beliefs. At night, the hole in the center only lets good dreams pass. Bad dreams are trapped in the web and dispelled at the first light of morning.
- Ancient traditions and beliefs can result in the creation of something beautiful and useful.
- All the parts of the dreamcatcher have meaning: the web represents the eternal web of life, weaving dreams and energy in the universe; the ring represents the earth and the circle of life; the beads on the web are blessings. The feathers represent a path for good dreams to slide down toward the dreamer while the wool of the webbing is a trap for bad dreams.
- How to arrange elements in an artwork so that they appear symmetrical or equally balanced.

DO: Create an original dreamcatcher design using the learned techniques which concentrate on overlapping and symmetry.

NOTES:
The tutorial provides a guide for creating a dreamcatcher; however, there are many different ways to design one. The inside webbing does not have to have a particular pattern, just as the number of beads and feathers can vary. Use your imagination to create your own dreamcatcher design.

VOCABULARY:

Culture – The inherited ideas, beliefs, values and knowledge which constitute the shared ideas of a social group.

Dream Catcher – A Native American craftwork consisting of a small hoop covered with woven string, yarn or other fabric/material and decorated with feathers and beads. It is believed to give its owner good dreams.

Weaving – The interlacing of long, thin materials, such as yarn or thread to make a design, cloth (fabric) or baskets.

Repetition – The act of repeating; a repeated action, performance, production, or presentation.

Starburst – A pattern of lines or rays radiating from a central point.

Symmetry / Symmetrical Balance – The parts of an image or object organized so that one side duplicates, or mirrors, the other.

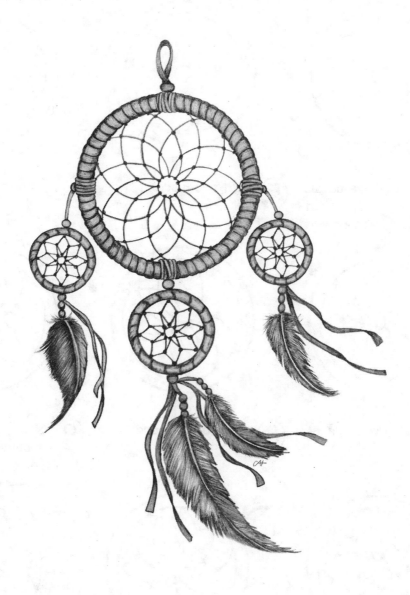

Dreamcatcher

page 1

1. Start with a tiny circle inside a larger circle.

2. Draw another circle inside the large one.

3. Next, draw 2 "petal" shapes surrounding the center circle.

4. Draw two more petals that overlap the first set as shown below.

5. Add two more . . .

6. . . . and two more . . .

7. . . . and two more . . .

8. . . . and one more!

9. Next, add curved lines around the outer ring for a "wrap" detail.

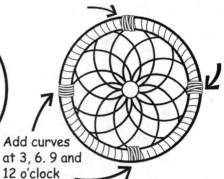

Add curves at 3, 6. 9 and 12 o'clock

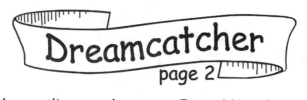

Dreamcatcher
page 2

10. Draw feather outlines as shown below. These are angled so they appear to be blowing in the wind.

11. Add beads and a vein line curving through the center of each feather.

<u>Feather TIP:</u>

make a raindrop shape

↓

turn it upside-down and curve it

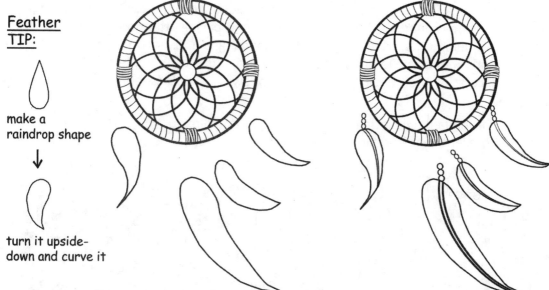

12. Attach feathers to the hoop with flowing ribbons. Draw small dots around the inner circle.

draw a "knot" on areas that overlap

13. Add a hanging loop at the top. Add "extra's" as desired.

check out the angled lines on each feather for detail

CVH

115

Doodling

Have you ever picked up a pen or pencil and began making designs or interesting marks on your paper while your teacher was lecturing in the classroom or your boss was talking non-stop in the boardroom?

"Stop doodling!" is a common response to this seemingly mindless act of drawing. When someone is doodling, it looks like they aren't paying attention, are bored, or are flat out being rude. Many believe that doodling is a distraction from the task at hand and hinders the learning process. After all, how can people be listening if they're decorating their papers with a maze of swirls, scribbles, and checkerboard patterns?

Teachers have been telling their students to stop doodling for years. However, contrary to popular belief, doodling has many benefits.

"Doodling" may seem like an activity for those not paying attention, but in fact, it's quite the opposite! Doodling can actually help kids and adults concentrate. It's not a mindless activity; rather, it engages the mind in a way that enhances thinking. Doodling is good for you!

Studies have shown that "sketching and doodling can improve our comprehension, creative thinking, and attention span" (Andrade, 2009). This means that many people who doodle and sketch during an activity can actually remember more than non-doodlers. A person who doodles is absorbing information while they are doodling.

The act of doodling during a lecture actually helps you retain more of what is being said aloud, reducing a person's need to daydream as they are forced to sit still and listen. Not only does it help one concentrate, it is a way of developing creative ideas. You don't need to be a great artist to doodle – you just need a little imagination. In fact, doodling can become great art, so doodle on.

References
Andrade, J. (2010), What does doodling do? Appl. Cognit. Psychol., 24: 100–106. doi: 10.1002/acp.1561

Zen Doodles

Doodling can be a relaxing and fun way to create beautiful images by drawing simple patterns. This next section focuses on a form of making art based on the popular trend of creating miniature pieces of unplanned, abstract, black and white art. Zen doodles are beautiful, fun, and relaxing to create. The word "Zen" reflects a high level of focus that incorporates the togetherness of body and mind, offering enlightenment and relaxation. "Doodle" means to draw something without thinking about what you are doing. The process of creating a piece of Zen doodle art is a form of "artistic meditation." The creator can become completely engrossed in making each pattern, deliberately focusing on one mark at a time. Simply put, Zen doodles can be the process of drawing a complicated design by combining several simple patterns or designs together while the mind enters a focused, relaxed, and meditative state.

The creative options and pattern combinations are endless, and anyone can do it. There are many benefits to doodling Zen-style as it provides artistic satisfaction along with exploring creativity and self-expression. It also provides a non-verbal outlet for entertainment, relaxation, problem-solving skills, building confidence, and improving hand-eye coordination – just to name a few.

This type of art is not intended to be a representation of something else. The doodle should be an unplanned, abstract, non-objective creation that grows organically as you make each deliberate stroke.

In other words, you should have no idea what your completed artwork will look like before you begin. The creation will change many times as you add lines, patterns, and designs to it. Zen doodles are usually spontaneous, self-paced, and repetitive; however, there is no true formula as to what makes a good doodle. If you are relaxed, focused, and drawing one line at a time, you are doing it right!

TIPS:

- There is no right side up or upside down — any way you hold the paper will look good.
- The work should be unplanned — the results should surprise you.
- The designs and patterns you draw should not represent anything in particular. Don't draw any numbers, letters, or pictures. Your marks should not contain recognizable objects and should be a strictly non-representational design.
- Start small, preferably with a 3.5" square of paper. This will enable you to concentrate on a tiny area at a time and add a lot of detail to it without rushing or feeling overwhelmed.

- Leave at least a 1/4-inch margin around the edges of the paper that will act as a frame for your design.

- Use all the space at your disposal, but do not cram in the content – white space (negative space) can be an important part of the layout.

- Create contrast; certain areas should have more "weight" or thicker lines and shapes to create interest. Zen doodles with an equal balance of black and white shapes/designs are the most pleasing to the eye.

- Don't erase. Oftentimes, this type of drawing is done with a fine black pen (no pencil) so that every single mark made on the paper is used. It also reinforces the idea that one should not have a plan when doodling, just to let it happen. The artwork evolves after each mark is made.

- A pattern develops over time. When creating a pattern, many people just make a simple design and then leave it as is. They don't think to go back and add more, but that is exactly what should be done. Start off with a few lines and designs, then go back in and make those designs more complex.

- If you get stuck, try the following exercise: Start with a line design. When that is completed, go back and add a line of squares (or some other shape) in between every other line. Then, go back again and add another shape or pattern inside the previous shape. Continue this process until the space has been filled up in an interesting way.

- Take a step back from your artwork. Ask yourself: does the doodle appear balanced or is it too heavy with darkness or lightness on one side? A good Zen doodle will have an equal balance of positive and negative space. That means that the artist may need to fill in many areas with solid black or closely spaced lines, leaving other areas white.

- Notice that in many of the patterns provided, the details are very close together. There's not a lot of white space in between each design, line, or pattern. This makes the artwork look "fuller" and more interesting/detailed.

- Try to combine at least five different patterns together to create a one-of-a-kind artwork.

- The following pages show just a few of the millions of patterns you can create. These are only guidelines for you to follow and by no means your only choices. Use these ideas for inspiration if you feel stuck. The goal is to create your own Zen Doodle.

- Most importantly, HAVE FUN!

Zen Doodle 1

1. Draw a border outlining the shape of the doodle. It is common to use a small square shape.

2. Draw lines to divide the square into sections.

3. Make some of the lines bolder to add contrast and interest.

Add a thin (very light) margin on each side as a border.

Lines can be symmetrical or asymmetrical, curved or not . . . you decide!

4. Fill one section with a repetitive pattern. Don't spend too much time planning, just draw . . .

5. Fill each section with a different pattern.

6. Go back over the patterns you created and add even more detail. Make sure there is contrast.

. . .the pattern will reveal itself as the drawing unfolds!

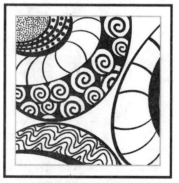

Focus on the patterns being drawn and pay attention to each line.

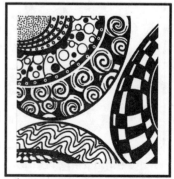

Keep going until you are done! Erase the border from step 1.

Zen Doodle 2

1.

Draw a thin (very light) border outlining the shape of the doodle.

2.

This time, instead of drawing sections of lines, draw a small shape or simple design.

3.

Continue to draw those same shapes using different sizes. Overlap them to create an interesting design.

Specifically Placed

1.

Draw a margin around the edges then add a small shape or design inside.

2.

Repeat the design using equal distances apart from one another to fill the space.

3.

Use thick and thin lines to fill the background. Keep going until you are satisfied.

Zen Doodle

Pattern Ideas

Triangles within triangles

X weave with dots

Striped Scales

Bubbles

Crazy string

Random spirals

Geometric swirl

Piano key stripes

Leaf circle

Vine spiral

Circles and pin stripes

Connected circles

Zen Doodle

More Pattern Ideas

Basket weave

Plant Spiral

Waves

Contrasting circles & triangles

Stripes and dots

Ribbon weave

Rattlesnake tails

Connected google eyes

Braids and dots

Tubes and rings

Layered ovals

Flower power

ZEN DOODLE ANIMAL

KNOW:
Asymmetry, Balance, Pattern, Positive and Negative Space, Silhouette, Symmetry

UNDERSTAND:
• How to create a successful silhouette of a recognizable object.
• Zen doodle animals can utilize random patterns or follow the natural lines of the body.

DO: Create an original Zen doodle animal using a variety of patterns combined to make a unique design. Start by breaking up large sections into "strings" and eventually focus on small shapes, lines, and designs within each section. Lastly, emphasize the positive and negative space within the outlined canvas to create a pleasing, balanced design.

NOTES: Try making up your own original, non-representational design/pattern that is different from the ones seen in the tutorial.

VOCABULARY:

Asymmetric – Not identical on both sides of a central line; not symmetrical.

Balance – The way the elements of art are arranged to create a feeling of stability in a work; a pleasing arrangement of parts in a design or composition.

Negative Space – Empty space in an artwork; a void.

Pattern – The repetition of any thing (shapes, lines, or colors) also called a motif, in a design.

Positive Space – Space in an artwork that is filled with something, such as lines, designs, color, or shapes.

Silhouette – A recognizable outline of an object.

Symmetry / Symmetrical Balance – The parts of an image or object organized so that one side duplicates, or mirrors, the other.

Zen Doodle Animal

Take your Doodle to the next level

1. Find or draw an outline (silhouette) of an animal, insect or other creature.

2. Draw strings inside. Strings are lines that divide the shape into individual sections.

Follow the natural shape of the animal or create a random pattern.

3. Fill a section with a pattern. Don't spend too much time planning it out, just draw . . .

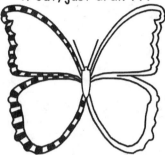

. . . the design will reveal itself as the drawing unfolds!

4. Add a different pattern to another section.

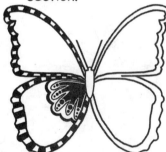

5. Next, add yet another pattern to complete that section.

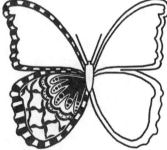

6. Look over the patterns you just made and add more details if needed.

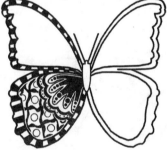

7. Continue to fill each area with a different pattern.

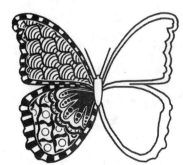

8. Focus on the design & pay attention to each line drawn.

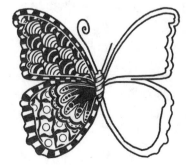

9. Try to replicate the same designs on the opposite side.

example of mirror symmetry

127

Zen Doodle Animal

Take your
Doodle to
the next level

1. Start with a silhouette of an animal, insect, etc.

2. Draw lines inside to separate the sections.
These lines can follow the natural form of your object.

3. Fill one section with a pattern.

4. Draw a different pattern on another section.

5. Fill another area with another pattern.

6. Draw another design inside yet another area.

7. Take your time and continue to fill each area with a different pattern or design.

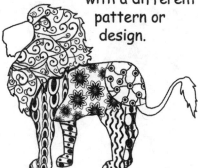

8. Make sure to add a a nice balance between black and white.

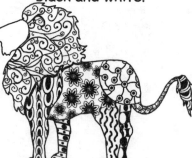

9. Keep drawing until the outline is filled.

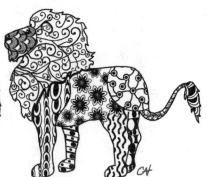

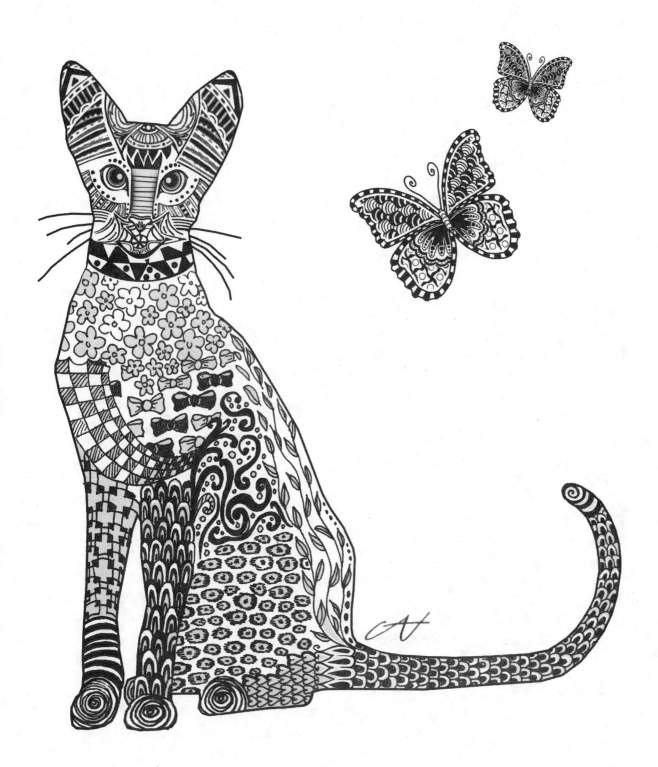

Chapter 4

Optical Illusions

OPTICAL ILLUSIONS

Optical illusions involve images that are sensed and perceived to be different from what they really are. This causes the brain to see one thing or misinterpret what it sees when the image is actually something completely different. The images in an optical illusion are examples of how the mind and the eyes can play tricks on each other. These illusions can be confusing and sometimes dizzying to look at but are always fun to create.

There are three main types of optical illusions. The first is the literal optical illusion, which shows an image that is different from what the actual image is. An example of this is an artwork made of many small objects placed together to create a larger object, portrait, or scene.

There are three main types of optical illusions. The first is the literal optical illusion which shows an image that is different from what the actual image is. An example of this is an artwork made of many small objects placed together to create a larger object, portrait or scene.

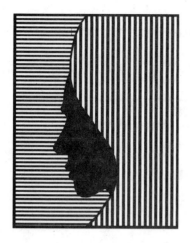

The second type of optical illusion is the physiological optical illusion. With this type of illusion, the brain presumes that the image is the result of an effect of excessive interaction or stimulation. The eyes and the brain are affected as a result of something happening with the color, contrast, size, or movement within an image.

The third type of optical illusion is the cognitive illusion, which affects unconscious inferences such as the distortion of an image or human perception. These can include geometric optical illusions, which distort length, shape, size, curvature, or position; ambiguous illusions, which offer more than one interpretation or double meaning; fictional illusions, which elicit the perception of a figure that isn't actually present; and paradox illusions, which appear to be improbable images.

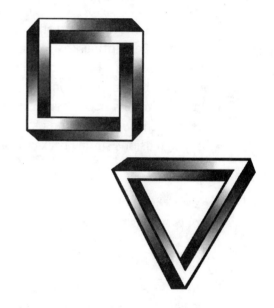

All optical illusions are designed to trick the eye and make the viewer perceive something that isn't actually there. They use color, contrast, patterns, lines, and shapes to create images that mislead our brains into forming a perception that doesn't match reality. This occurs because the brain tries to interpret information logically, but the eye sends a conflicting message.

Check out the following pages for a sampling of how to draw a few cool optical illusions.

GEOMETRIC SHAPE ILLUSION

KNOW:
Geometric Shape, Illusion, Illusory Motion, Optical Art

UNDERSTAND:
- Op art, also known as optical art, is a style of visual art that makes use of optical illusions. Op artworks create an impression of movement on the picture surface. This is also known as Perceptual Abstraction.
- Optical illusions can use color, light, and patterns to create images that can be deceptive or misleading to our brains.
- Optical illusions occur because our brain is trying to interpret what we see and make sense of the world around us.
- Optical illusions simply trick our brains into seeing things which may or may not be real.

DO:
Create simple op-art patterns using parallel lines and geometric shapes to make an original optical illusion design using pattern and repetition.

VOCABULARY:

Geometric Shape – Any shape having more mathematic than organic design. These are typically made with straight lines or shapes from geometry, including circles, ovals, triangles, rectangles, squares, etc.

Illusion – A deceptive or misleading image or idea.

Illusory Motion – Also known as motion illusion, it is an optical illusion in which a static image appears to be moving due to the cognitive effects of interacting color contrasts or shape position.

Op Art – An art style in which the impression of movement is created on the picture surface by means of optical illusion; also known as Optical Art or Perceptual Abstraction.

Parallel – Two or more straight lines or edges on the same plane that do not intersect. Parallel lines have the same direction.

Pattern – The repetition of checkerboard pattern-marked by alternating squares of different colors, lines, materials, shades, or shapes.

Geo-Illusion

1. Start by drawing a series of geometric shapes as shown. Placing them off center and at an angle adds interest.

2. Draw lines through the corner points of each shape so an "X" is made in the smallest, center shape.

3. Add two or three geometric shapes on top of the design.

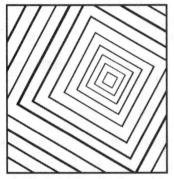

Squares are used above, however, any single shape can be used successfully.

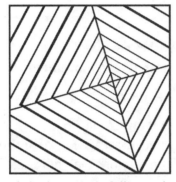

If the lines don't fall exactly on the corner points, that's OK. Just get it close.

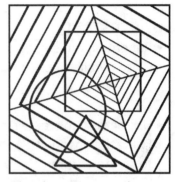

The shapes can overlap one another.

4. Choose an area inside one of the shapes drawn in step 3. Fill in every other block with a solid color.

5. Continue filling in every other closed-in area using a checkerboard pattern. Pay close attention to which areas are being filled.

6. The final artwork will appear as an intricate geometric design that shows illusory motion.

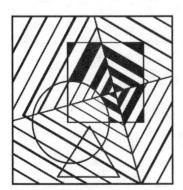

Stop adding fill when another shape line intersects.

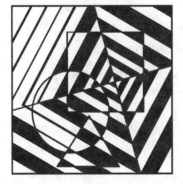

No two blocks of color should touch if possible.

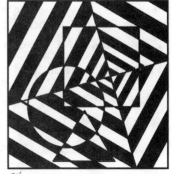

FACE PROFILE ILLUSION

KNOW:

Line, Optical Illusion, Parallel, Pattern

UNDERSTAND:

- Repetition can create unity within a work of art.
- Close parallel lines can appear to create movement when used in optical illusion art.

DO:

- Use pattern to create a detailed optical illusion.
- Using the tips and tricks provided, draw a series of horizontal, vertical, and diagonal lines to create an interesting, unique artwork that indicates movement.

TIPS:

- Use a ruler!
- If using a ruler with a marker, the marker can tend to smudge easily if the ruler is slid from one area to another without letting the ink dry. To avoid this, simply lift up the ruler and place it into position as opposed to sliding it into position.

VOCABULARY:

Line – Any line that is clearly drawn and marks direction.

Optical Illusion – An image that deceives a person, leading to a misinterpretation of its meaning.

Parallel – Two or more straight lines or edges on the same plane that do not intersect. Parallel lines have the same direction.

Pattern – The repetition of shapes, lines or colors.

Check out "Human Face Profile" in the "Cool Stuff" chapter for how to draw a face view from the side

Face Profile Illusion

Use a Ruler! (to make the lines)

1. Start by drawing the "Human Face Profile" (as seen in this book) or draw one from memory. It should go off the page as shown.

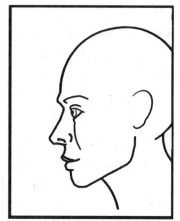

2. Erase all of the inside details so only the profile silhouette remains.

3. Add an interesting curved line that separates the face from the rest of the head.

4. Using a ruler and a thin marker or pen, draw a series of lean, horizontal lines in the area outside of the face. Be careful not to smudge!

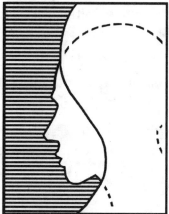

Erase dotted area inside curve . . .

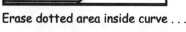

5. Using a ruler, draw a series of lean, vertical lines inside the "hair" area, leaving the face blank.

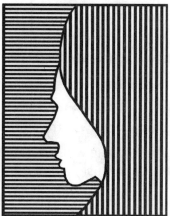

6. Color the face in solid or design a colorful pattern inside the blank area to create the feeling of movement.

137

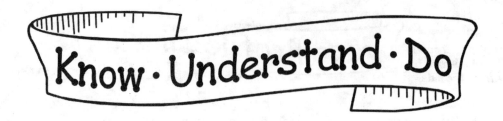

MAN IN A BOX

KNOW:
Perspective, Optical Illusion, Differences between near and far objects in a scene

UNDERSTAND:
• The illusion of depth can be created when using the One-Point Perspective technique.
• When One-Point Perspective is used, all lines appear to meet at a single point
• Receding lines create straight edges that appear to go back into space.

DO:
• Create an original artwork using a vanishing point and receding lines.
• Following the techniques provided, create the illusion of the inside of a 3D room or box that appears larger at the outer opening and smaller as the lines recede toward the center. Shade and add a person (or creature or other item) in the back of the "box" to indicate the illusion of someone (or something) at the "far" end of the room/box.

TIPS:
• Use a ruler!
• Draw lightly as the center lines and vanishing point inside of the smallest square will be erased.
• Shade using a "checkerboard" pattern to create interest.

VOCABULARY:
Checkerboard – A pattern consisting of alternating dark and light squares, often black and white.

Line – Any line that is clearly drawn and marks direction.

One Point Perspective – A form of linear perspective in which all lines appear to meet at a single point on the horizon.

Receding lines – Lines that move back or away from the foreground.

Vanishing Point – A point on a horizon line where lines between near and distant objects appear to meet in order to produce an illusion of depth.

Man in a Box

Draw lightly . . . there will be a bit of erasing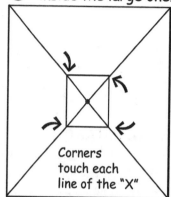

1. Draw a large box with an "X" through it.

Ends of "X" touch each corner

2. Add a vanishing point in the center of "X".

Vanishing point in center

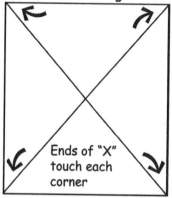

3. Draw a small square inside the large one.

Corners touch each line of the "X"

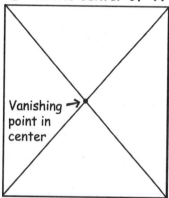

4. Draw a cross inside the large square.

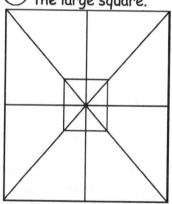

5. Draw another square inside the large one.

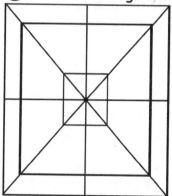

6. Find center of each section & mark a dot.

outer edges have 8 dots

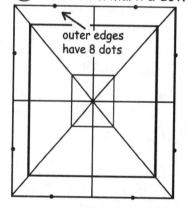

7. Connect outer dots to center point as shown.

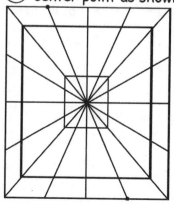

8. Fill remaining space in center with squares.

Erase middle

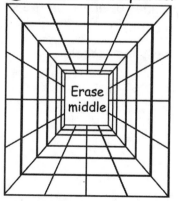

9. Shade checkerboard pattern and add man.

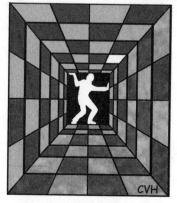

CVH

139

OP ART CUBE

KNOW:
Illusion, Op-Art, Parallel, Pattern

UNDERSTAND:
- Optical illusions occur because our brain is trying to interpret what we see and make sense of the world around us.
- Optical illusions simply trick us into seeing things that may not be real.

DO:
- Use a pattern to create a detailed optical illusion.
- Learn about and use complementary colors in a piece of artwork.

VOCABULARY:

Hexagon – A polygon with six edges and six vertices. A vertex (plural: vertices) is a corner or a point where two or more straight lines meet.

Illusion – A deceptive or misleading image or idea.

Op Art – An art style in which an impression of movement is created on the picture surface by means of optical illusion; also known as Optical Art or Perceptual Abstraction.

Optical Illusion – An image that deceives a person, leading to a misinterpretation of its meaning.

Parallel – Two or more straight lines or edges on the same plane that do not intersect. Parallel lines have the same direction.

Pattern – The repetition of shapes, lines or colors.

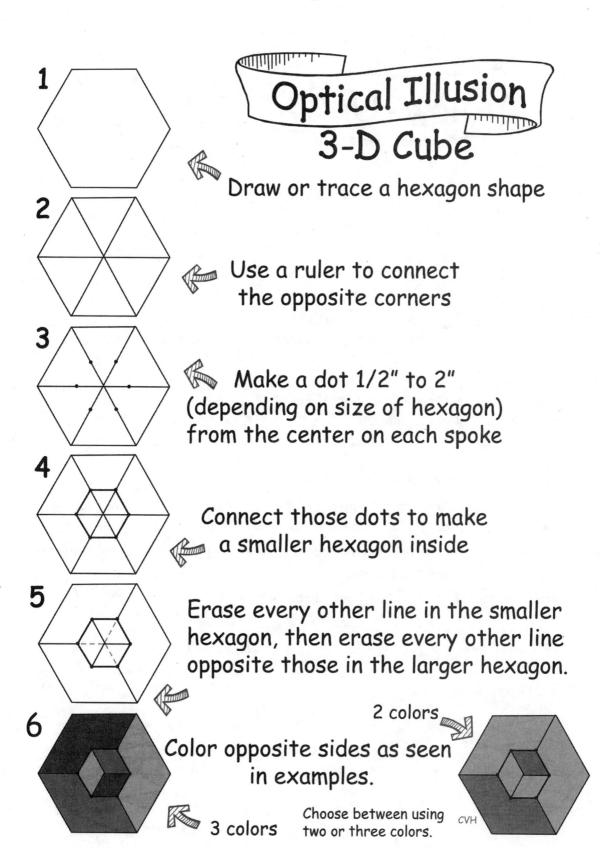

1 Draw or trace a hexagon shape

2 Use a ruler to connect the opposite corners

3 Make a dot 1/2" to 2" (depending on size of hexagon) from the center on each spoke

4 Connect those dots to make a smaller hexagon inside

5 Erase every other line in the smaller hexagon, then erase every other line opposite those in the larger hexagon.

6 Color opposite sides as seen in examples.

2 colors

3 colors Choose between using two or three colors.

CVH

Optical Illusion
3-D Cube

OP ART HAND

KNOW:
Illusion, Op-Art, Parallel, Pattern

UNDERSTAND:
- Repetition can create unity within a work of art.
- Optical illusions simply trick our brains into seeing things which may or may not be real.

DO:
- Use a pattern to create a detailed optical illusion.
- Add shading or pattern for interest.

VOCABULARY:

Illusion – A deceptive or misleading image or idea.

Op Art – An art style in which an impression of movement is created on the picture surface by means of optical illusion, also known as Optical Art or Perceptual Abstraction.

Parallel – Two or more straight lines or edges on the same plane that do not intersect. Parallel lines have the same direction.

Pattern – The repetition of shapes, lines, or colors.

Op Art Hand

1.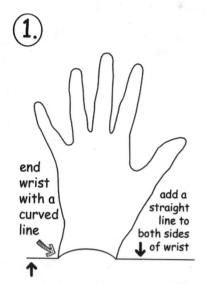

end wrist with a curved line

add a straight line to both sides ↓ of wrist

Start by tracing your hand palm down.

TIP: To get the best hand shape, keep your pencil at a 90°angle.

2.

Draw another curved line above the one you just drew. Draw the straight lines as well. (Make sure the straight lines are parallel)

3.

Repeat step 2 all the way up into the fingers. Curve each finger individually. The lines outside of the hand will stay straight.

4.

Once the hand curves are complete, add straight lines above and below until your paper is full.

5.

Erase your original hand tracing. Be careful not to erase the curves and straight lines you just made.

6.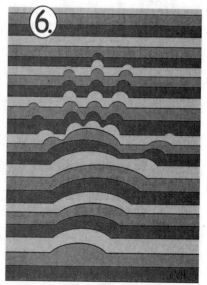

Color! Make every other line an alternating color or create your own repetitive pattern to complete the illusion.

STRAIGHT LINE SPIRAL

KNOW:
Parabolic curves, Spiral

UNDERSTAND:
How to create a spiral using only straight lines.

DO:
The basic principle of this design is the creation of curved shapes from the intersection of straight lines. Follow the "Straight Line Spiral" information sheet to understand how to make a parabolic curve. Use inspiration and the tutorial provided to create a unique Straight Line Spiral.

TIPS:
• Leave no more than one finger width at the base of each triangle drawn for the best results.
• Add details such as pattern, texture, or shading to make it your own!

VOCABULARY:
Line – Any line that is clearly drawn and marks direction. Line is one of the seven Elements of Art; a moving dot with direction.

Parabolic Line Patterns – Repeated straight lines that eventually appear to create curves in art and architecture.

Spiral – A curve on a plane that winds around a fixed center point at a continuously increasing or decreasing distance from the point.

Straight Line Spiral

This can be done with a square or a rectangle

1. Draw a straight line from the top left corner of the paper to the top right edge leaving space as shown.

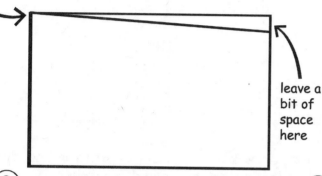

leave a bit of space here

2. Next, draw a straight line from where the last line ended to the lower right edge as shown to form another long triangle.

here

to here

3. Next, draw a straight line from where that line ended to the bottom left corner.

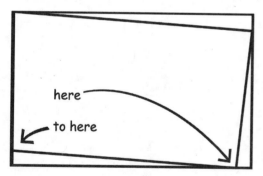

here

to here

4. Finally, draw a straight line from where that line ended to the upper left edge. Repeat steps 1-4.

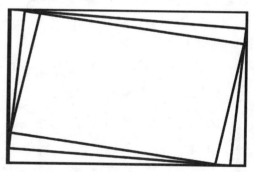

5. Keep going until there is no more space to draw lines.

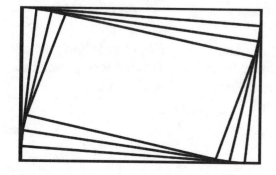

6. This will create four rounded curves made from straight lines. The closer the lines, the rounder they appear.

 use a ruler!

Parabolic Curve

①.

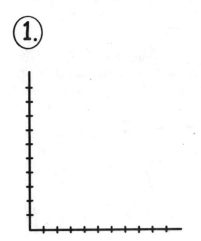

Start with a right angle. Draw notches of equal intervals on the lines as shown.

②.

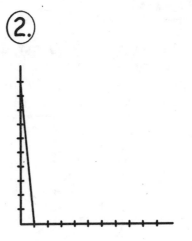

Using a ruler, draw a line from the top left notch to the bottom left notch.

③.

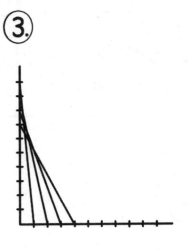

Repeat with the 2nd, 3rd and 4th notches.

①.

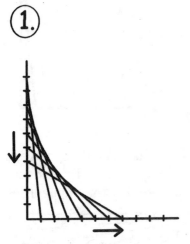

Continue moving down the left side and out on the bottom.

⑤.

Repeat until you reach the bottom notch on the left and the last notch on the far right.

⑥.

Erase notch marks and fill in every other box with a hue.

STRAIGHT LINE HEART

KNOW:
Parabolic curves, Symmetry

UNDERSTAND:
How to create a heart using only straight lines.

DO:
The basic principle of this design is the creation of curved shapes from the intersection of straight lines. Follow the "Straight Line Heart" information sheet to understand how to make a parabolic curve. Use inspiration and the tutorial provided to create a unique Straight Line Heart.

TIPS:
- Leave no more than one finger width at the base of each triangle drawn for the best results.
- Add details such as pattern, texture, or shading to make it your own! This activity can get a bit tricky with all of the closely spaced lines being used. Pay close attention to where the lines start and end.

VOCABULARY:
Line – Any line that is clearly drawn and marks direction. Line is one of the seven Elements of Art; a moving dot with direction.

Parabolic Line Patterns – Repeated straight lines that eventually appear to create curves in art and architecture.

Symmetry – The parts of an image or object organized so that one side duplicates or mirrors the other.

Straight Line Heart

①.

Start by lightly drawing a circle, find the center and make marks at 90 degree intervals as seen above.

TIP: Try and find a circle to trace

②.

use a ruler or just 'eye it up'

1
2
3
4
5
6
7
8

Make small marks at 10 degree intervals all the way around the circle. There should be eight marks between each line made in step 1.

③.

Draw a line connecting two of the main marks as seen above. This will become part of the pointy base of the heart.

④.

1

4 2

3

Next, connect the mark to the right of mark "3" to the mark directly above mark "2" (shown with arrows). Continue to connect the marks this way.

⑤.

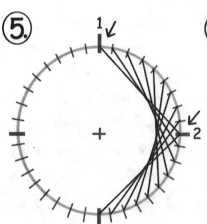

1

2

Stop when mark 2 is connected to mark 1 (indicated above by arrows).

⑥.

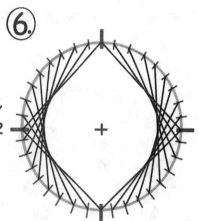

Do the same thing on the opposite side.

next >

149

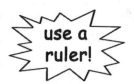
use a
ruler!

Straight Line Heart continued . . .

⑦

Count two lines to the left of the center, upper mark and start the next line. Connect it to the first line next to the 3 O'clock mark on the right side of the circle. (See arrows)

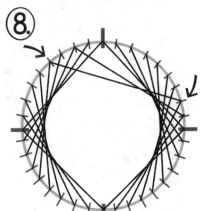

⑧

Count two more lines over from the left of the mark started in step 7. Connect it to the second line above the 3 O'clock mark on the right side of the circle. (See arrows)

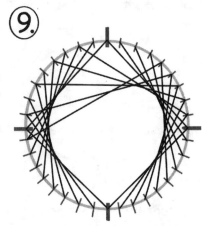

⑨

Keep connecting the marks by counting two marks for the starting point of the lines and two marks for the ending points.

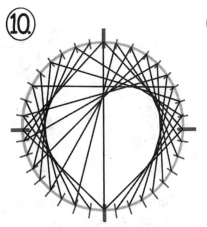

⑩

Continue until the top right curve of the heart is complete.

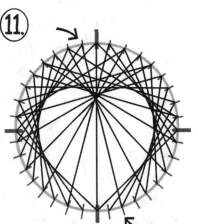

⑪

Repeat on the opposite side.

⑫

Erase the guide marks and darken the outer circle when the artwork is complete.

Parabolic Diamond

①.

Start by drawing a plus sign. Make lines at equal intervals on all sides. Lightly number them as shown.

②.

Working in the right upper quadrant, draw a straight line from the top number 1 dot to the other number 1 dot as shown.

③.

Connect the number 2 dot to the number 2 dot, 3 to 3 and so on.

④.

This time, work in the lower right quadrant. Connect the number 7 dot to the number 7 (not the 1's this time) the 6 to the 6 and so on.

⑤.

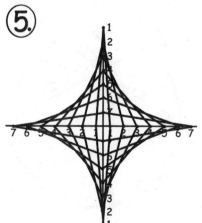

Repeat steps 2-4 on the left upper and lower quadrants.

⑥.

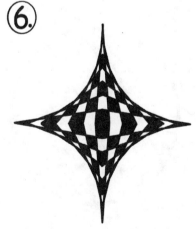

Erase the dots, numbers and the center line. Use a checkerboard pattern to color if desired.

Parabolic Circle

①

Draw a circle: use a compass or find a circle to trace.

②

Draw notches around the circle, equally distant from one another.

③

Draw a line from the top center to the bottom right corner. It should look like the side of a triangle.

④

Move up one line from the left and one line over from the center. Connect with a line.

⑤

Continue moving around the circle, connecting the notches with lines.

⑥

Keep going all the way around the circle. Each notch will have 2 lines touching it. Erase notches when they are no longer needed.

ANAMORPHIC WRITING

KNOW:
Anamorphic Art, Distortion

UNDERSTAND:
Text painted on roads as signage and directional arrows are designed anamorphically (stretched out) so that these signs are easily understood by the drivers who must view them obliquely.

DO:
View and discuss images of anamorphic art. Choose a word or phrase that has six or more letters that you'll "draw" onto graph paper. Holding your paper vertically, use a ruler to create one letter per grid column, stretching your letters so they are just a few rows from the top and bottom of your paper. Continue writing each letter until the word is complete.

TIPS:
• Leave at least two spaces between each word and a half to one full column space between each letter so the words will be easier to read.
• Go over your letters in marker after you draw them in pencil so they stand out.
• Create one letter per column but use two columns for wider letters like "M" and "W".
• Share your work with others and see if they can read what you designed!

VOCABULARY:
Anamorphosis and Anamorphic Art – An image appears distorted because it is constructed on an elongated grid, rendering it unintelligible until it is viewed from a specific point of view or reflected in a curved mirror. "Anamorphosis" is a Greek word meaning transformation.

Distort – To change the way something looks; sometimes deforming or stretching an object or figure out of its normal shape to exaggerate its features to make it more interesting or meaningful.

Line – Any line that is clearly drawn and marks direction. Line is one of the seven Elements of Art; a moving dot with direction.

Oblique – Neither perpendicular nor parallel to a given line or surface; slanting; sloping.

Example of Distortion in Art: Hans Holbein (German, 1497/8–1543) created "The Ambassadors," an oil painting of two men posing with some objects. A human skull is painted in the lower third of the painting but appears distorted. The skull appears undistorted only when the painting is viewed at an angle.

Anamorphic Writing

1. Hold a piece of graph paper vertically. Choose a word to write that has six or more letters in it.

vertical

2. Using a ruler, create one letter per column.

stretch your letters so they are just a few rows from the top and a few rows from the bottom (letter D >)

3. Skip one column space the start the next letter.

leave half to one full column space between letters so the word is easier to read later

skip 1 full or 1/2 column between letters

4. Continue until the word is complete. Skip two columns to start a new word.

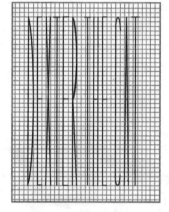

make sure your letters start and end at the same row line

5. Tilt your paper at an extreme angle so your words are easier to read.

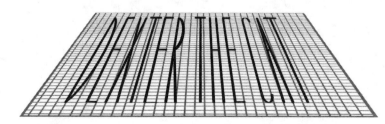

TIPS:

Go over your letters with a bright colored marker so they stand out

Always use a ruler

Create one letter per column but use two columns for wider letters like "M" or "W"

Share your work with your friends and test them to see if they can read your anamorphic writing!

An **impossible object** is a type of optical illusion.

Optical illusions are often described as visual images that differ from reality; the information gathered by the eye is processed by the brain and creates a perception that does not match the true image. As we take information in through our eyes, our brain tries to interpret what we see to make sense; however, an optical illusion tricks us into seeing things that cannot exist in the real world. These impossible constructions violate the laws of geometry.

When viewing an impossible object, the initial impression of a 3D object is offered, but the impossibility usually becomes apparent after viewing the figure for a few seconds.

Our eyes want to interpret these drawings as three-dimensional objects but they are not based in reality upon closer inspection. The lines connect in unrealistic ways that are unsettling. Looking at different parts of the object makes one reassess the 3D nature of the object, which confuses the mind.

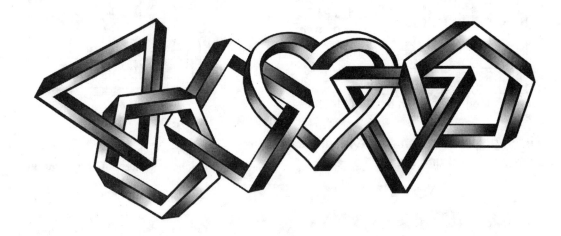

Although it is possible to represent impossible objects in two dimensions, it is not geometrically possible for these objects to exist in the physical world. Some 3D constructions of impossible objects have been created that offer the *illusion* of impossibility when viewed from a very specific point. However, these cannot be considered true 3D representations of impossible objects because the illusion cannot be maintained when the object is rotated or the viewpoint is changed.

There are hundreds of impossible objects that can be created through drawing, but only a fraction of them are shown on the next few pages.

What impossible objects can you create?

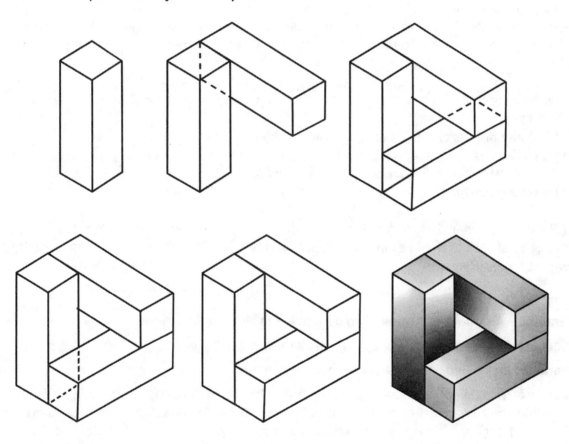

THE IMPOSSIBLE TRIANGLE

KNOW:
Equilateral Triangle, Parallel Lines, Optical Illusion

UNDERSTAND:
- Our brain puts information together in a way that makes sense and allows us to see optical illusions in different ways.
- How to create the illusion of an Impossible Triangle where the beams of the triangle simultaneously appear to recede into the distance and come toward the viewer.

DO:
- View optical illusions and discuss how the brain can be deceived by puzzling visual challenges.
- View and discuss examples of "Impossible" objects in art.
- Using the tips and guidelines provided, test and enhance the power of your observation and critical thinking skills by creating a version of the Impossible Triangle using measurements and shading.

TIP: Before drawing dark, permanent lines with a ruler, lightly sketch guidelines to indicate the general area of the lines in each step. It is very difficult to draw these lines perfectly without measurements.

VOCABULARY:
Gradual – A smooth transition from dark to light values, little by little

Equilateral Triangle – A triangle in which all three sides are equal.

Parallel Lines – Two lines on a plane that never meet.

Penrose Triangle – Also known as the "Penrose Tribar" or "Impossible Triangle," this impossible object was first created by Swedish artist Oscar Reutersvärd in 1934, who drew it as a set of cubes in parallel projection. It is featured prominently in the works of M. C. Escher, who was partly inspired by earlier depictions of impossible objects. His version was painted as three bars connected at right angles.

Optical Illusion – An image that deceives a person, leading to a misinterpretation of its meaning

More information: In 1961, artist M.C. Escher created the lithograph "Waterfall" based on the principles of the Impossible Triangle.

Also known as the "Penrose Triangle"

The Impossible Triangle

Pay attention to the arrows in this lesson!

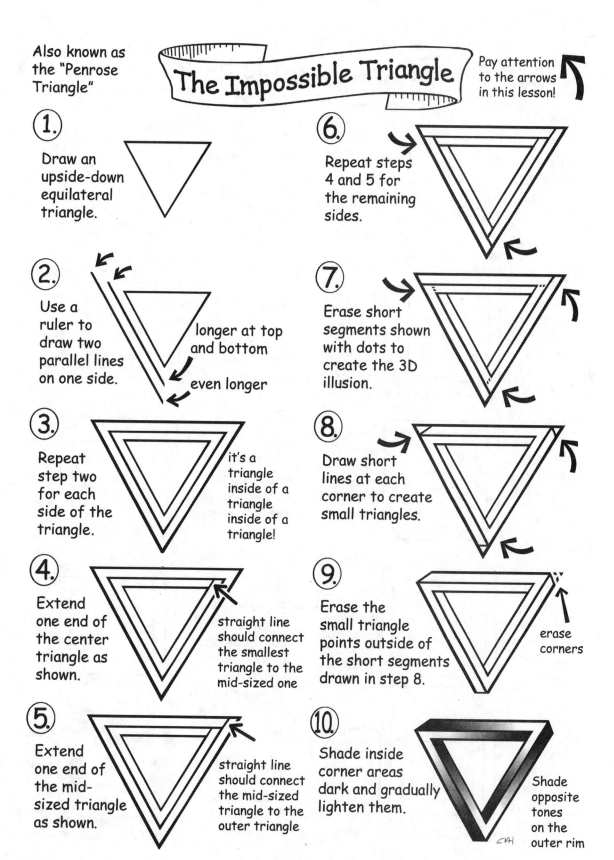

1. Draw an upside-down equilateral triangle.

2. Use a ruler to draw two parallel lines on one side.

longer at top and bottom

even longer

3. Repeat step two for each side of the triangle.

it's a triangle inside of a triangle inside of a triangle!

4. Extend one end of the center triangle as shown.

straight line should connect the smallest triangle to the mid-sized one

5. Extend one end of the mid-sized triangle as shown.

straight line should connect the mid-sized triangle to the outer triangle

6. Repeat steps 4 and 5 for the remaining sides.

7. Erase short segments shown with dots to create the 3D illusion.

8. Draw short lines at each corner to create small triangles.

9. Erase the small triangle points outside of the short segments drawn in step 8.

erase corners

10. Shade inside corner areas dark and gradually lighten them.

Shade opposite tones on the outer rim

CVH

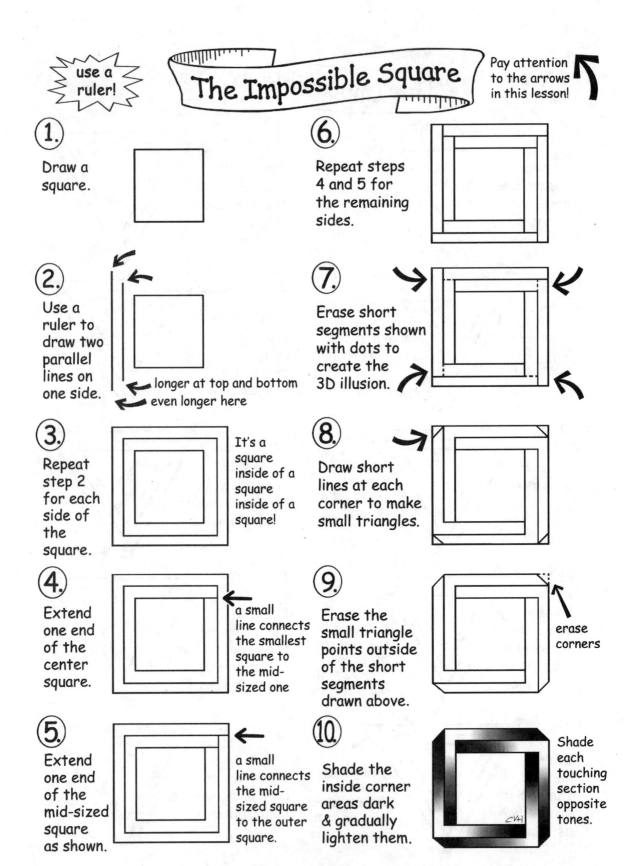

use a ruler!

The Impossible Square

Pay attention to the arrows in this lesson!

1. Draw a square.

2. Use a ruler to draw two parallel lines on one side.

longer at top and bottom
even longer here

3. Repeat step 2 for each side of the square.

It's a square inside of a square inside of a square!

4. Extend one end of the center square.

a small line connects the smallest square to the mid-sized one

5. Extend one end of the mid-sized square as shown.

a small line connects the mid-sized square to the outer square.

6. Repeat steps 4 and 5 for the remaining sides.

7. Erase short segments shown with dots to create the 3D illusion.

8. Draw short lines at each corner to make small triangles.

9. Erase the small triangle points outside of the short segments drawn above.

erase corners

10. Shade the inside corner areas dark & gradually lighten them.

Shade each touching section opposite tones.

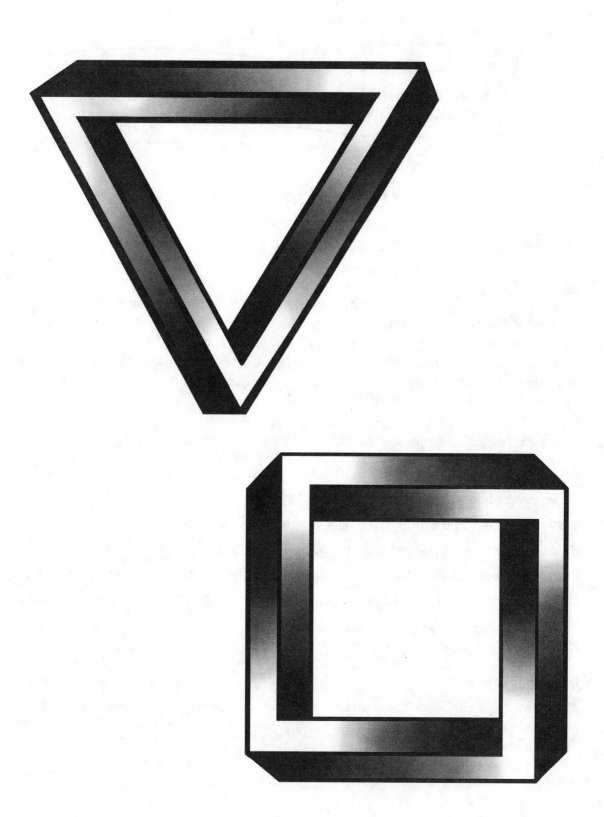

THE IMPOSSIBLE HEART

KNOW:
Horizontal Lines, Parallel Lines, Optical Illusion

UNDERSTAND:
• Our brain tries to put information together in a way that makes sense and allows us to see optical illusions in different ways.
• The importance of using guidelines for accuracy when drawing.
• How to create the illusion of an Impossible Heart where the beams and curves of the heart simultaneously appear to recede and come toward you.

DO:
Create a version of the Impossible Heart using measurements and shading.

VOCABULARY:
Curve – A continuously bending line, without angles.

Gradual – A smooth transition from dark to light values, little by little.

Guide Lines – A lightly marked line used as a guide when composing a drawing.

Horizontal Lines – Straight and flat across, parallel to the horizon. The opposite is vertical.

Optical Illusion – An image that deceives a person, leading to a misinterpretation of its meaning.

Parallel Lines – Two lines on a plane that never meet.

Interesting Fact:

All impossible figures are somewhat possible. A three-dimensional object that looks impossible from a single point of view can be created. It would look ordinary from all other points of view.

Use a ruler for step 1

The Impossible Heart

Pay attention to the arrows in this lesson!

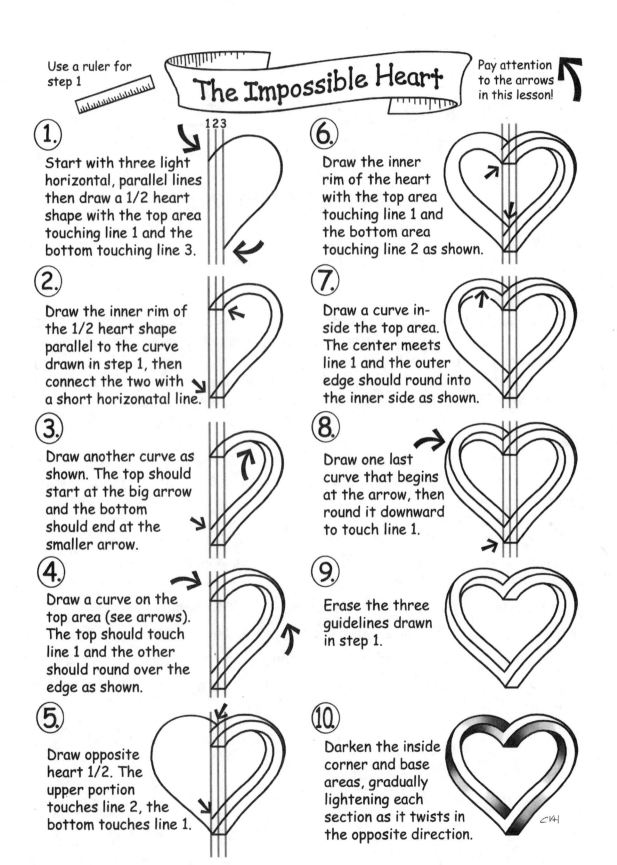

1. Start with three light horizontal, parallel lines then draw a 1/2 heart shape with the top area touching line 1 and the bottom touching line 3.

2. Draw the inner rim of the 1/2 heart shape parallel to the curve drawn in step 1, then connect the two with a short horizonatal line.

3. Draw another curve as shown. The top should start at the big arrow and the bottom should end at the smaller arrow.

4. Draw a curve on the top area (see arrows). The top should touch line 1 and the other should round over the edge as shown.

5. Draw opposite heart 1/2. The upper portion touches line 2, the bottom touches line 1.

6. Draw the inner rim of the heart with the top area touching line 1 and the bottom area touching line 2 as shown.

7. Draw a curve in-side the top area. The center meets line 1 and the outer edge should round into the inner side as shown.

8. Draw one last curve that begins at the arrow, then round it downward to touch line 1.

9. Erase the three guidelines drawn in step 1.

10. Darken the inside corner and base areas, gradually lightening each section as it twists in the opposite direction.

163

THE IMPOSSIBLE PENTAGON

KNOW:
Equilateral Triangle, Pentagon, Parallel lines, Optical illusion

UNDERSTAND:
- Illusions are special perceptual experiences in which information arising from "real" external stimuli leads to an incorrect perception, or false impression, of the object or event from which the stimulation comes.
- How to create the illusion of an Impossible Pentagon where the angles simultaneously appear to recede into the background and come toward the foreground.

DO:
- Discuss how the brain can be deceived by puzzling visual challenges.
- Using the tips and guidelines provided, create an Impossible Pentagon using measurements and shading.

VOCABULARY:
Equilateral Triangle – A triangle that has all its sides equal in length. It is also called an equiangular triangle, where each angle measures 60 degrees

Gradual – A smooth transition from dark to light values, little by little.

Pentagon – A geometrical shape, which has five sides and five angles.

Parallel Lines – Two lines on a plane that never meet.

Optical Illusion – An image that deceives a person, leading to a misinterpretation of its meaning.

The Impossible Pentagon

Pay attention to the arrows in this lesson!

1. Draw a light cross shape as a guide. Draw a pentagon.

← triangle

upside down trapezoid

2. Use a ruler to draw two parallel lines on one side.

long here
even longer

3. Repeat step 2 for each side. Erase the cross.

It's a pentagon inside a pentagon inside a pentagon

4. Extend one end of the center pentagon.

5. Extend one end of the mid-sized pentagon as shown.

6. Repeat steps 4 and 5 for the remaining sides.

7. Erase short segments shown with dots to create the 3D illusion.

8. Draw short lines at each corner to make small triangles.

9. Erase the small triangle points outside of the short segments drawn above.

erase corners

10. Shade the inside corner areas dark & gradually lighten them.

CVH

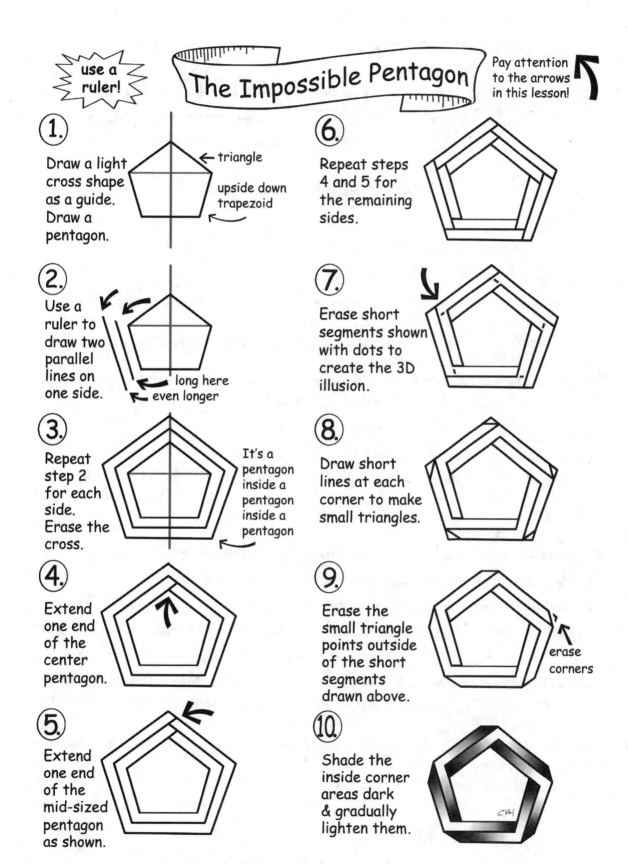

THE IMPOSSIBLE STAR OF DAVID

KNOW:
Equilateral Triangle, Parallel Lines, Optical Illusion, Star of David, Hexagram

UNDERSTAND:
• An optical illusion is a visual stimulus perceived by the eyes and then comprehended by the brain in a way that is different from reality.

• Because of its geometric symmetry, the hexagram has been a popular symbol in many cultures from the earliest times.

• How to create the illusion of an Impossible Star of David with lines that simultaneously appear to recede and come toward you at the same time.

DO:
• View and discuss examples of "Impossible" objects in art.

• Using the tips and guidelines provided, create an Impossible Star of David using measurements and shading.

VOCABULARY:
Gradual – A smooth transition from dark to light values, little by little.

Equilateral Triangle – A triangle in which all three sides are equal.

Parallel Lines – Two lines on a plane that never meet.

Optical Illusion – An image that deceives a person, leading to a misinterpretation of its meaning.

Star of David – Also known in Hebrew as the **Shield of David** or **Magen David**, it is a generally recognized symbol of modern Jewish identity (although not *exclusively* Jewish) in the shape of a hexagram, the compound of two equilateral triangles.

Hexagram – The symbol was used as a decorative motif in medieval Christian churches and Jewish synagogues.

 use a ruler!

Impossible Star of David

 1.

Draw a triangle, inside a triangle, inside a triangle.

 2.

Extend some of the lines so they touch the triangle next to it.

 3.

Draw short lines at each corner to make small triangles.

 4.

Draw a large, upside down triangle as shown.

 5.

Erase the triangle points outside the short segments drawn in step 3.

Draw a triangle inside the triangle drawn in step 4.

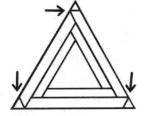

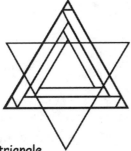

6.

Draw another triangle inside that triangle. Draw short lines at each corner.

7.

Erase the triangle points outside the short segments drawn in step 6.

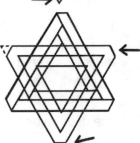

8.

Erase areas indicated by the dashed lines as shown. Look carefully!

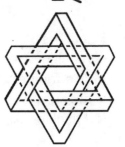

9.

Add lines where indicated so that they are connected as shown.

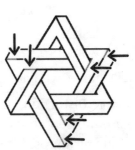

10.

Shade the inside corner areas dark & gradually lighten the plane until it's white.

Shade each touching section the opposite tone

167

THE ENDLESS STAIRCASE
Also known as **"The Impossible Staircase"** or **"The Penrose Staircase"**

KNOW:
Perspective Distortion

UNDERSTAND:
- Sometimes your brain fills in gaps when there is incomplete information or creates an image that isn't even there.
- How to create the illusion of an Impossible Staircase where the highest or lowest step cannot be determined.

DO:
- View "The Impossible Staircase," following the staircase around and trying to determine the lowest or highest step. What happens when the eye follows the stairs in a clockwise direction? In a counterclockwise direction?
- Using the tips and guidelines provided, test and enhance the power of your observation and critical thinking skills and create a version of the Endless Staircase using lines and shading.

VOCABULARY:
Gradual – A smooth transition from dark to light values, little by little.

Parallel Lines – Two lines on a plane that never meet.

Perspective Distortion – An image that appears normal because different regions of the image are focused upon. Each of those regions makes sense alone, but viewed together they create an impossible situation.

Optical Illusion – An image that deceives a person, leading to a misinterpretation of its meaning.

More information:

A figure by the mathematician L.S. Penrose, this idea was used as the basis for M.C. Escher's artwork: "Ascending and Descending."

Endless Staircase

1. Start with a basic cube that is elongated vertically.

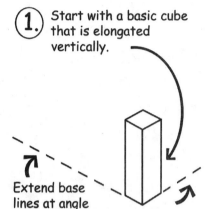

Extend base lines at angle as shown

2. Add another elongated cube to the right of the first. This one is slightly taller.

shorter taller

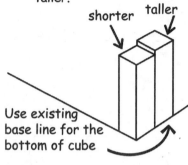

Use existing base line for the bottom of cube

3. Add a third elongated cube to the right of the second. This should be slightly taller than the second.

taller →
shorter →

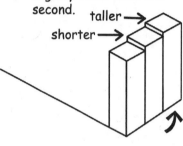

4. Fill the entire left line with cubes.

Each cube gets lower Start here (at #1) then keep adding cubes to the left

6 5 4 3 2 1

5. Add two more cubes that ascend from the cube drawn in step 3.

Leave off this line →

6. Working from left to right, add descending cubes at the back.

1 2 3 4

7. Add the last cube. It should overlap a tiny bit as shown.

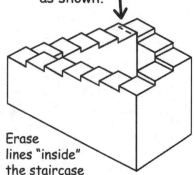

8. Erase the part of the cube "underneath" as shown.

Erase lines "inside" the staircase

9. Shade the inside left wall and outside right wall dark as shown.

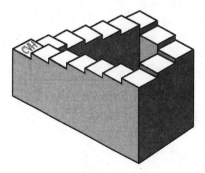

Chapter 5

Cool Stuff

Know · Understand · Do

CHAIN LINK HEART LOCK

KNOW:
Overlapping, Pattern, Repetition

UNDERSTAND:
- The elements of a pattern repeat in a predictable manner.
- How to create the appearance of interlocking forms by using overlapping techniques and shading.

DO:
- Create a realistic chain of interlocking links using the tips and tricks provided.
- Loop a unique shape (such as the heart shown) through the links as a "lock" fixture.
- Erase some areas on each link to create a metallic "shine" effect.

VOCABULARY:

Overlapping – When one thing lies over and partly covers something else.

Pattern – The repetition of shapes, lines, or colors.

Repetition – A way of combining elements of art so that the same elements are used over and over again.

Chain Heart Lock

Draw lightly . . . there will be a bit of erasing

① Start with 2 ovals.

↑ overlap

② Add triangle below.

Triangle goes through → base of circles

Edges touch

③ Erase lines inside.

④ Draw 1/2 oval at top of heart as shown below.

⑤ Add two chain links at a slight angle.

overlap overlap

These look a bit like rounded rectangles

⑥ Draw two ovals on both sides as shown.

An oval inside an oval

Erase dotted line

⑦ Add two more links. Angle them upward.

Erase dotted areas inside both links

⑧ Draw another oval

on each side as shown.

⑨ Add rounded rectangles at each end.

Keep adding links until the space is filled.

⑩ Curve links upward as you draw them

⑪

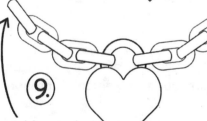

CVH

Erase some areas near the "front" of each link for highlights

Shade below the rounded retangles so they appear "on top" of the ovals

Shade and add a keyhole.

HOURGLASS

KNOW:
Geometric Shapes, Highlight, Stipple, Texture, Transparent, Value

UNDERSTAND:
- A transparent object allows us to see through a form.
- How to arrange elements in an artwork so that they appear symmetrical or equally balanced.
- How to create an effective design using simple shapes.
- How to create the appearance of texture.

DO:
- Follow the steps provided to create an original Hourglass design that starts with connected circles.
- Use learned 3D techniques which concentrate on overlapping and shading to convey the illusion of depth.
- Create the illusion of transparency by showing sand texture through the glass.

VOCABULARY:
Balance – A principle of design, balance refers to the way the elements of art are arranged to create a feeling of stability in a work; a pleasing or harmonious arrangement or proportion of parts or areas in a design or composition.

Highlight – The area on any surface which reflects the most light; to direct attention to or emphasize an area of a drawing through use of value.

Stipple – To make numerous small dots or specks in a drawing to create tone and texture.

Texture – The way something looks like it might *feel* in an artwork. Simulated textures are suggested by an artist with different brushstrokes, pencil lines, etc.

Transparent – Allowing light to pass through so that objects can be clearly seen on the other side; the opposite of opaque.

Value – An element of art that refers to the lightness or darkness of a color.

Hourglass

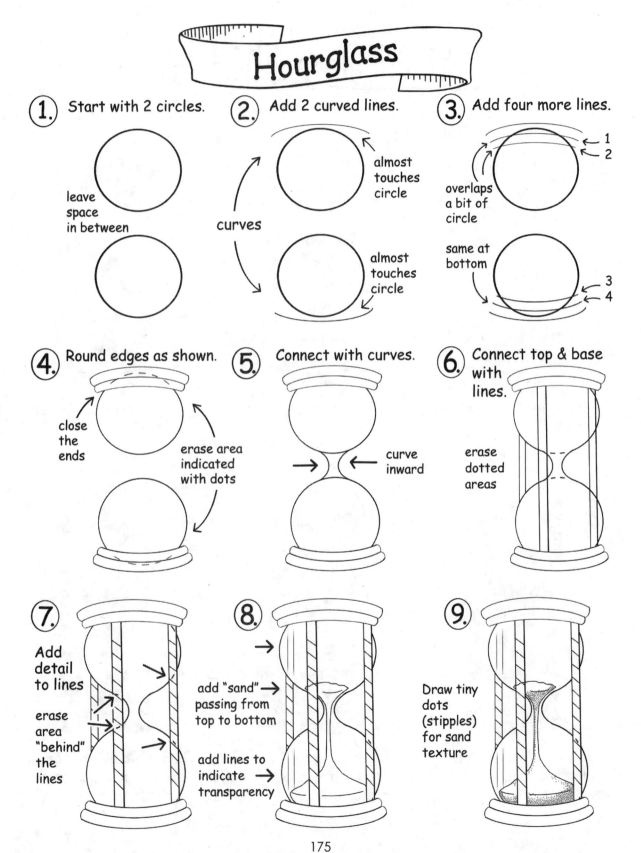

1. Start with 2 circles.

leave space in between

2. Add 2 curved lines.

almost touches circle

curves

almost touches circle

3. Add four more lines.

1
2

overlaps a bit of circle

same at bottom

3
4

4. Round edges as shown.

close the ends

erase area indicated with dots

5. Connect with curves.

curve inward

6. Connect top & base with lines.

erase dotted areas

7.

Add detail to lines

erase area "behind" the lines

8.

add "sand" passing from top to bottom

add lines to indicate transparency

9.

Draw tiny dots (stipples) for sand texture

Hourglass Shading

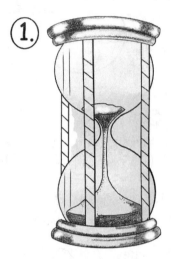

1. Shade in the darkest areas first.

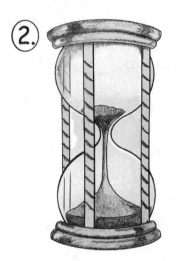

2. Next, add the mid-tones.

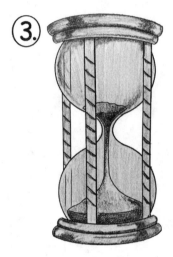

3. Then, add the lightest tones.

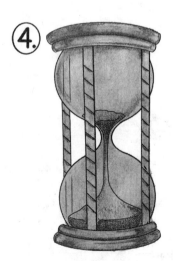

4. Smooth tones with a blending tool.

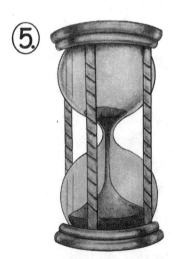

5. Add back some tone that was smoothed away. Blend in the outlines so they are not as visible.

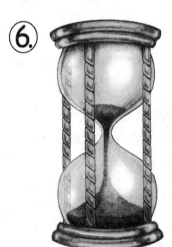

6. Erase highlighted areas for a shine. Deepen the darkest tones.

BASEBALL CAP

KNOW:
• Simple shapes combined together can create more complex objects
• How to create a sense of depth in an artwork

UNDERSTAND:
Varying the size of object parts in a drawing can help to achieve the illusion of depth.

DO:
Create an original artwork of a baseball cap that shows depth by following the steps provided

VOCABULARY:
Oval – An egg-like, two-dimensional shape that looks like a circle but has been stretched to make it longer. The two ends of an oval may or may not be the same size and shape.

Perspective – The technique used to create the illusion of 3D onto a 2D surface. Perspective helps to create a sense of depth or receding space.

Trapezoid – A quadrilateral plane figure having two parallel and two nonparallel sides. (A quadrilateral is a plane figure having four sides and four angles.)

Baseball Cap

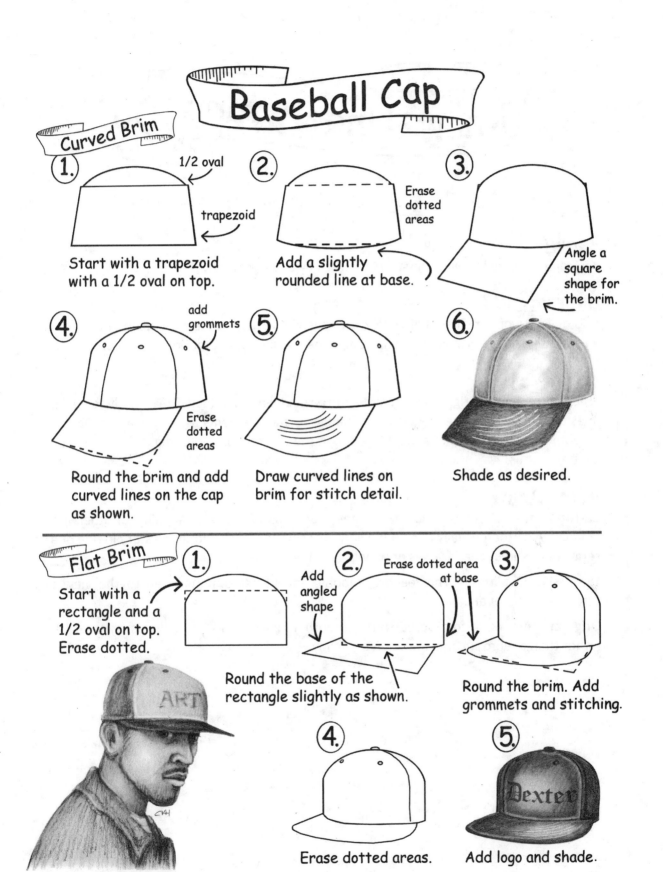

Curved Brim

1. Start with a trapezoid with a 1/2 oval on top.

1/2 oval
trapezoid

2. Add a slightly rounded line at base.

Erase dotted areas

3. Angle a square shape for the brim.

4. Round the brim and add curved lines on the cap as shown.

add grommets
Erase dotted areas

5. Draw curved lines on brim for stitch detail.

6. Shade as desired.

Flat Brim

1. Start with a rectangle and a 1/2 oval on top. Erase dotted.

2. Add angled shape. Round the base of the rectangle slightly as shown.

Erase dotted area at base

3. Round the brim. Add grommets and stitching.

4. Erase dotted areas.

5. Add logo and shade.

179

BOBBLEHEAD RAGDOLL

KNOW:
You can make original cartoon-style creatures by using geometric shapes.

UNDERSTAND:
• To make a work original, that work must have elements that are not copied or traced.
• Expressive qualities in your drawing add a feeling, mood, or emotion to your character.

DO:
Practice creating an original character using the guidelines provided. Draw lightly so guidelines can be erased if needed. Add or change certain elements as necessary to make it unique. Try to create a character NOT seen in the tutorial. Use your imagination and add a lot of "extras."

VOCABULARY:
Cartoon – A simple drawing created to get people thinking, angry, laughing, or otherwise amused. A cartoon usually has simple lines, uses basic colors, and tells a story in one or a series of pictures called frames or panels.

Expressive Qualities – The feelings, moods, and ideas communicated to the viewer through a work of art.

Original – Any work considered to be an authentic example of the works of an artist, rather than a reproduction, imitation or a copy.

Bobblehead Ragdoll

1. Start with a body made from simple shapes . . .

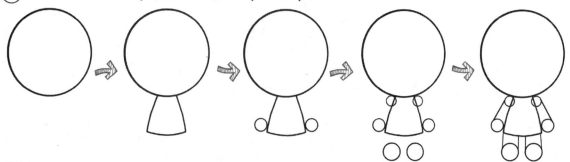

2. Next, choose an expressive set of eyes - draw them small and set them far apart.

3. Then, choose an expressive mouth and nose to work with your eyes.

4. Finally, add as many details as you need to build a unique, interesting character.

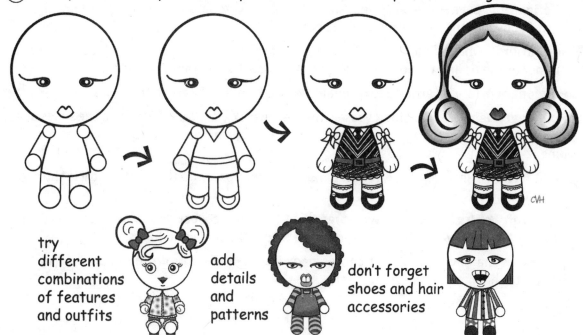

try different combinations of features and outfits

add details and patterns

don't forget shoes and hair accessories

CVH

HUMAN HEART

UNDERSTAND:
The major parts of the human heart.

KNOW:
The human heart is a muscle that sends blood throughout your body, giving it the oxygen it needs. The average human heart pumps about 70 milliliters of blood with every beat. That's about five liters every minute, or about 7,200 liters every day.

DO:
Draw your own version of the human heart and label the major parts.

NOTE:
There are many different angles and views of the human heart; this is just one of them!

VOCABULARY:
Heart – A muscular organ about the size of a closed fist that lies to the left of the chest and functions as the body's circulatory pump.

Inferior Vena Cava – The large vein that carries deoxygenated blood from the lower half of the body into the right atrium of the heart.

Left Atrium – One of four chambers in the heart that receives oxygenated blood from the pulmonary veins and pumps it into the left ventricle via the mitral valve.

Pulmonary Artery – Carries deoxygenated blood from the heart to the lungs.

Pulmonary Veins – Large blood vessels that receive oxygenated blood from the lungs and drain into the left atrium of the heart. There are four pulmonary veins, two from each lung.

Right Atrium – Receives deoxygenated blood and pumps it into the right ventricle through the tricuspid valve.

Right/Left Ventricle – One of two large chambers that collect and expel blood received from an atrium towards the peripheral beds within the body and lungs.

Superior Vena Cava – Vein that carries deoxygenated blood from the upper half of the body into the right atrium of the heart.

Human Heart

1. Lightly draw a circle. Add a rounded tip at the side bottom. This will be the main heart.

extend & round the base

2. Add a similar shape to the upper left as shown. Erase dotted line.

3. Erase area inside the shape drawn in step 2. Add a smaller 1/2 oval on the right.

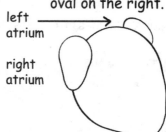

left atrium →

right atrium

4. Add a curved shape that overlaps as shown. This will be the pulmonary artery.

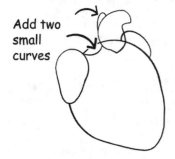

Add two small curves

5. Add a "Y" shaped tube extending from the right atrium. This will be the Superior vena cava.

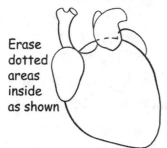

Erase dotted areas inside as shown

6. Add arch connecting Superior vena cava to pulmonary artery.

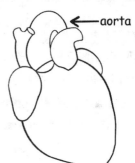

← aorta

7. Draw three tubes at the top curve of the aorta. Erase dotted.

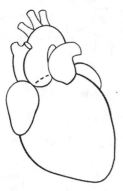

8. Add more tubes as shown. Erase dotted.

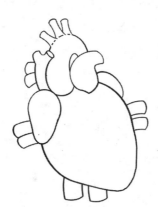

9. Add veins. Label parts if desired.

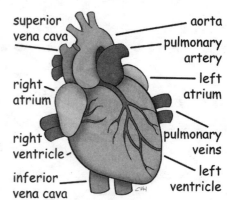

superior vena cava

right atrium

right ventricle

inferior vena cava

aorta

pulmonary artery

left atrium

pulmonary veins

left ventricle

PALM OF THE HAND

KNOW:
Creating a likeness from observation

UNDERSTAND:
By using simple shapes and overlapping ovals as guidelines, a realistic hand can be drawn.

DO:
• Practice drawing your hand using observation and the proposed techniques.
• Make the darkest values between the fingers and knuckle creases. This will indicate texture of the skin. Erase some spots on the finger pads and between the creases to create a natural highlight effect.

VOCABULARY:
Highlight – The area on any surface which reflects the most light; to direct attention to or emphasize an area of a drawing through use of value.

Texture – The way something looks like it might *feel* in an artwork. Simulated textures are suggested by an artist with different brushstrokes, pencil lines, etc.

Palm of the Hand

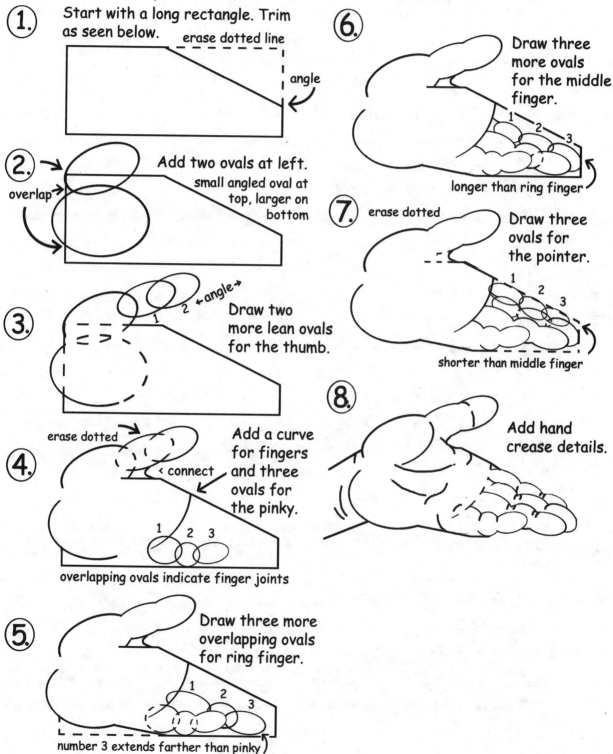

1. Start with a long rectangle. Trim as seen below.

erase dotted line

angle

2. Add two ovals at left.

overlap

small angled oval at top, larger on bottom

3. Draw two more lean ovals for the thumb.

←angle→

2

1

4. Add a curve for fingers and three ovals for the pinky.

erase dotted

‹ connect

1 2 3

overlapping ovals indicate finger joints

5. Draw three more overlapping ovals for ring finger.

1 2 3

number 3 extends farther than pinky

6. Draw three more ovals for the middle finger.

1 2 3

longer than ring finger

7. erase dotted

Draw three ovals for the pointer.

1 2 3

shorter than middle finger

8. Add hand crease details.

1. Fill in the areas with the deepest tone first.

Dark areas include the base of the hand and in the creases.

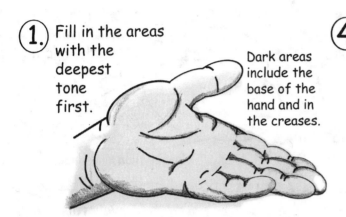

2. Next, add the mid-tones.

Mid-tones are next to the darkest tones.

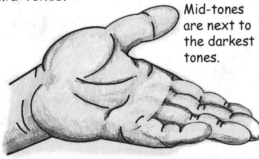

3. Blend tones to smooth them into one another.

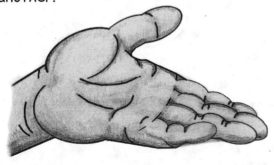

4. Start to blend in or erase the hard outlined edges.

Reshape the fingers to smooth out the oval guidelines.

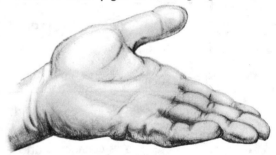

5. Soften edges with a kneaded eraser. Remove some pigment for highlights.

6. Deepen tones and erase for high-lights as needed.

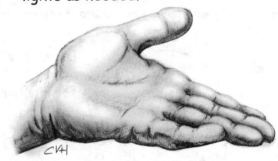

CVH

KOI FISH

KNOW:
• Overlapping
• Scalloped Texture
• Layer

UNDERSTAND:
• Drawing simple shapes is the first step to creating complex forms.
• Overlapping and layering items help create a sense of depth and realism.

DO:
Create an original artwork of a koi fish following the steps provided. Use shading and scalloped texture for realism. Add "extras" including a background or Asian symbols for interest.

VOCABULARY:

Detail – A part of a whole; a distinctive feature of an object or scene which can be seen most clearly close up.

Layer – Something placed over another surface. In this artwork, the scales will be layered.

Overlap – When one thing lies over, partly covering something else. Depicting this is one of the most important means of conveying the illusion of depth.

Scallop – One of a series of similar curves that form a decorative edge on something.

Texture – The way something looks like it might *feel* in an artwork. Simulated textures are suggested by an artist with different brushstrokes, pencil lines, etc.

Start with layered scales

Lightly shade

Darken the center

Add a peaceful
symbol to your work

水

Japanese symbol for water

Draw a Koi

光明

Japanese symbol for glory,
hope, bright future

1. Start with a circle.
Draw a curved line
dividing the shape.

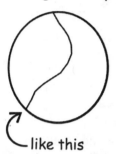

like this

2. Erase the dotted area.
Add a lip, eye and fin.

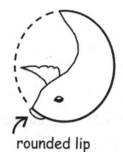

rounded lip

3.

Add a point shape here.

Curve a line
down the back
for fins.

Add a small
curve here.

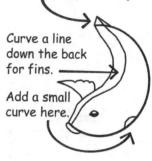

4.

Add two
curved
lines at tail

Draw
curved
head

Add fin

Erase

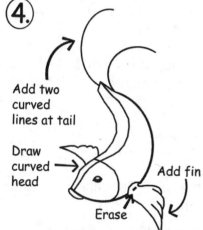

5.

close tail with
scalloped "V"

Add detail
to fin line
on back

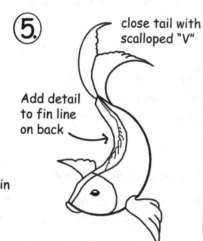

6.

TIPS

start with a
1/2 circle

add another
touching it

add another
in between

Start
adding
scales

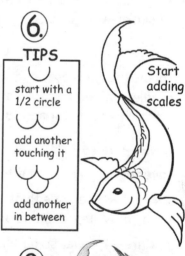

7.

Fill the body
with scales

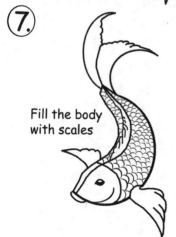

8.

Add fin detail

Add whiskers

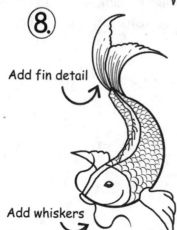

9.

Add design
in
background

Shade

Add
symbols

光明

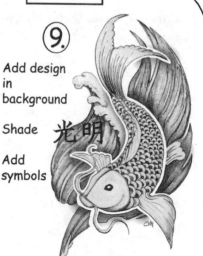

TEDDY BEAR

KNOW:
• Layering, Overlapping
• Texture

UNDERSTAND:
• Drawing simple shapes is the first step to creating complex forms.
• Overlapping and layering shapes help to create a sense of depth and realism.
• The techniques an artist uses to show how something might feel or what it is made of in an artwork.

DO:
Follow the steps provided and create your own version of a teddy bear. Begin by layering simple geometric shapes and connecting them to create more complex, organic forms. Add "extras" like fur and stitching and then shade.

VOCABULARY:
Layering – To place something over another surface or object.

Overlap – When one thing lies over, partly covering something else. Depicting this is one of the most important means of conveying an illusion of depth.

Texture – The way something looks like it might *feel* in an artwork. Simulated textures are suggested by an artist with different brushstrokes, pencil lines, etc.

Teddy Bear

1. Start with three circles; two at the top and one near the bottom.

small →

large

push this one over to the right a bit →

2. Add ovals for ears.

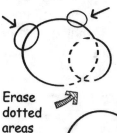

Erase dotted areas

3. Lightly draw two ovals for the arm.

Erase dotted areas

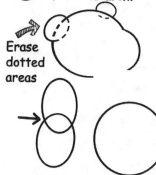
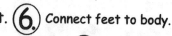

4. Add second arm on right as shown.

connect shoulder →

connect head to belly

Erase dotted areas

slight overlap

5. Add two ovals for feet.

space here ↓

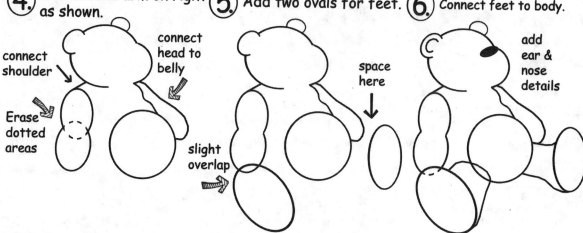

6. Connect feet to body.

add ear & nose details

7. Add eyes and mouth.

Erase dotted areas

Add belly button and belly wrinkles

8. Add paw detail on feet.

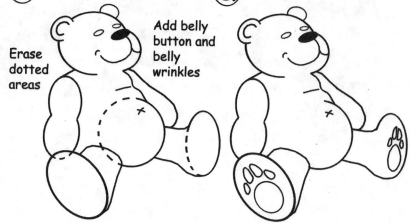

See next page for shading information . . .

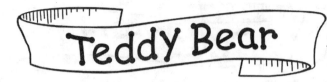

Teddy Bear SHADING

1. Fill in the whole bear with a light layer of tone.

Fill in the eyes

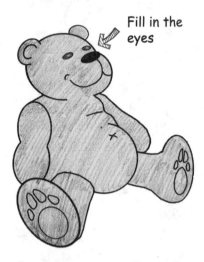

2. Add a layer of dark tone on the undersides of shapes and in the creases.

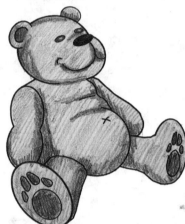

3. Smooth tones with a blending tool.

4. Draw hatch marks around the contour of the bear to indicate a fur texture.

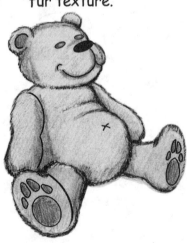

5. Fill in the eyes and feet. Add texture to inner arm and mouth.

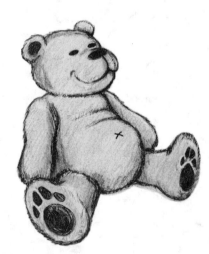

6. Add more texture lines as needed.

Add shiny spots in eyes and nose

dots for whiskers

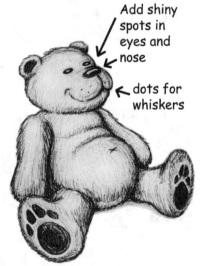

Know · Understand · Do

THE "T" TRAIN

KNOW:
Perspective

UNDERSTAND:
- How to create a sense of depth in an artwork.
- Overlapping and differences in the size of objects in a scene help to achieve the illusion of depth.
- Drawn objects that appear close to us are large and usually close to the bottom of the page. Objects that appear farther from us in a drawing are usually small and higher on the page.

DO:
Follow the steps provided to create a subway train that indicates perspective.

VOCABULARY:

Perspective – The technique used to create the illusion of 3D onto a 2D surface. Perspective helps to create a sense of depth or receding space.

Tips for Tracks

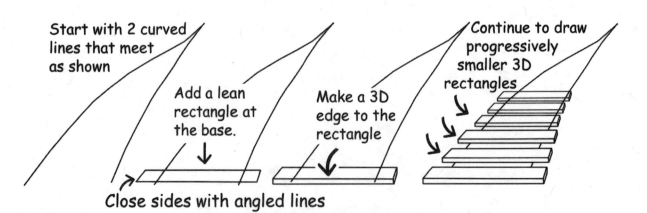

Start with 2 curved lines that meet as shown

Add a lean rectangle at the base.
↓

Make a 3D edge to the rectangle
↙

Continue to draw progressively smaller 3D rectangles

Close sides with angled lines

The "T" train

1. Start with a square.

→ not centered

2. Trim corners. Add curve at base. (erase dotted)

3. Add rectangle door. Add another curve at base.

→

4. Add headlights.

5. Add windows.

6. Round inner door.

7. Add window in door, rectangle above door and hook at front

two circles

8. Add two small rectangles and line by door base.

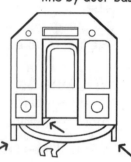

9. Add "T" logo. Extend train so it recedes.

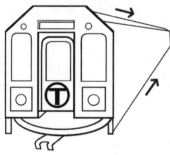

10. Add windows.

11. Add receding track.

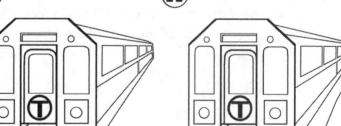

TYRANNOSAURUS REX

KNOW:
• Overlapping
• Texture

UNDERSTAND:
• Drawing simple shapes is the first step toward creating complex forms.
• Overlapping and layering items help to create a sense of depth and realism.

DO:
Create an original artwork of a Tyrannosaurus Rex following the steps provided. Use shading and texture for realism.

VOCABULARY:
Detail – A part of a whole. A distinctive feature of an object or scene which can be seen most clearly close up.

Layer – Placing something over another surface.

Overlap – When one thing lies over, partly covering something else. Depicting this is one of the most important means of conveying an illusion of depth.

Texture – The way something looks like it might *feel* in an artwork. Simulated textures are suggested by an artist with different brushstrokes, pencil lines, etc.

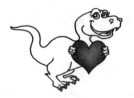

Tyrannosaurus Rex has tiny arms . . . but a big heart!

① Start with an oval and a small circle.

overlap here

This is the body

② Add an oval head and connect with curved neck lines.

head

③ Add two ovals for mouth. Include a tiny eye circle.

erase dotted areas

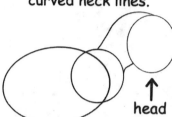

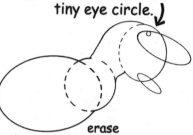

④ Add front and back legs.

erase dotted areas

geometric shapes

ovals

⑤ Draw triangle mouth, nostril, face lines and lip details.

add bumps

bumps

erase dotted areas

⑥ Add foot details, wrinkles, tongue and belly detail.

toe detail sample (overlap)

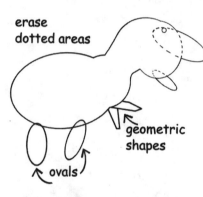

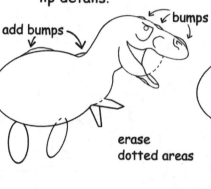

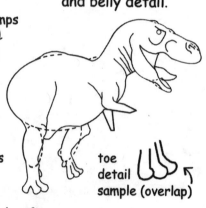

⑦ Add pointy teeth, claws, curved tail and more wrinkles.

Geometric tail shape

claw detail

rounded end with overlapping hook shape

Add claws here

⑧ Extend and refine the tail. Erase dotted guidelines.

Tyrannosaurus Rex
SHADING

1. Add a layer of dark tone to the areas of shadow.

2. Fill in the remainder of the dino with a medium layer of tone.

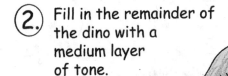

3. Use a blending tool to smooth the tones.

4. Deepen the dark tones and use an eraser on areas of highlight. Smooth as needed.

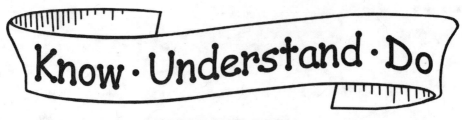

SIMPLE SKELETON

KNOW:
• Layering, Overlapping
• Simple steps to create a realistic human skeleton
• Major bones of the human body

UNDERSTAND:
• Overlapping simple shapes is the first step to creating complex forms.
• The basics of proportion to create a human skeleton.

DO:
Follow the steps provided and create your own version of a human skeleton. Begin with layering simple geometric shapes and connect them to create a more complex form.

VOCABULARY:
Femur – Thigh bone.

Fibula – Calf bone located on the lateral side of the tibia.

Humerus – Bone of the upper arm.

Layering – To place something over another surface or object.

Overlap – When one thing lies over, partly covering something else. Depicting this is one of the most important means of conveying an illusion of depth.

Pelvis – Ring-like structure of bones at the lower end of the trunk.

Radius – The shorter of the two long bones of the forearm.

Skull – Bony structure, the head in the skeleton that supports the structures of the face and forms a cavity for the brain.

Spine – Vertebral column, also known as the backbone, is a bony structure found in vertebrates. It is formed from individual bones called vertebrae.

Tibia – The larger and stronger of the two bones in the leg below the knee in vertebrates.

Ulna – The longer of the two bones of the forearm, the other being the radius.

LOOK!

Simple Skeleton

1. skull →

Start with a stick body as seen here

2. erase dotted areas

"Thicken" the neck

Add hands and feet

"Mittens" for hands

3. Add eye shape

sternum →

Add rib outline

4. Add a nose

humerus

radius

ulna

"Thicken" the arm bones

Simple Bone

Wide and bumpy at ends

Thin in the center

5. Add detail to the spine and neck area

vertebrae

TIP:
Vertebra can be drawn as cylinders with ovals on each side

a.

b.

c.

d.

The adult human body is seven heads high

Simple Skeleton
continued

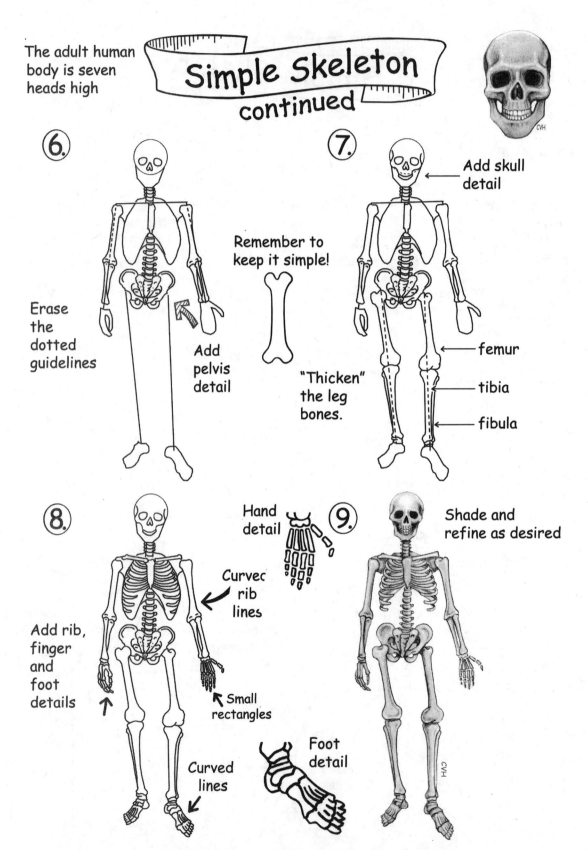

The adult human body is seven heads high

⑥.

Erase the dotted guidelines

Add pelvis detail

Remember to keep it simple!

"Thicken" the leg bones.

⑦.

Add skull detail

femur

tibia

fibula

⑧.

Add rib, finger and foot details

Curved rib lines

Small rectangles

Curved lines

Hand detail

⑨.

Shade and refine as desired

Foot detail

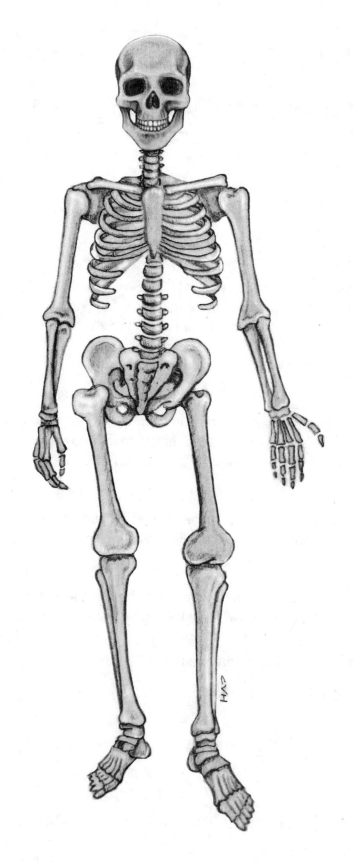

DACHSHUND DOGGIE

KNOW:
Balance, Curve, Geometric shapes

UNDERSTAND:
- Shading using value will achieve a more realistic rendering.
- How to arrange elements in an artwork so that they appear symmetrical or equally balanced.
- How to create an effective design using simple shapes.

DO:
Follow the steps provided and create your own version of a dachshund dog. Begin by drawing simple geometric shapes and connecting them to create a more complex, organic shape that resembles the breed. Add "extras" like wrinkles and texture.

EXTRA CREDIT:
Follow the steps to draw a dog but place the body shape circles far apart to create a super-long pup! Hold your paper horizontally or diagonally for maximum length.

VOCABULARY:
Balance - A principle of design, balance refers to the way the elements of art are arranged to create a feeling of stability in a work; a pleasing or harmonious arrangement or proportion of parts or areas in a design or composition.

Combine – Two or more objects put together.

Geometric Shape – A non-organic shape that utilizes rectilinear or simple curvilinear motifs or outlines in design.

1. Start with two circles

larger smaller

The distance between the circles will determine how long the dog will be

2. Add another small circle for the head. Connect the body.

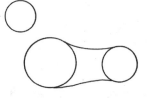

3. Connect the head with curved lines. Erase dotted portions of the body circles as shown.

add 1/2 oval for muzzle

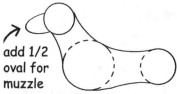

4. Add ovals for top of legs and paws. Add an angled ear.

erase circle parts in head not needed

5. Connect the legs. Add a tail and an eye.

bump

curve

bend

slight bump

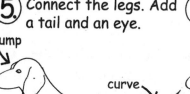

6. Erase dotted areas as shown. Add a second set of legs "behind" the first set.

leg

leg→

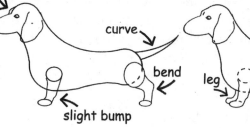

7. Add a nose, erase dotted area.

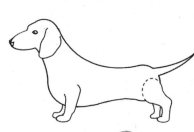

8. Add wrinkles in body, paw detail and mouth.

detail

tiny mouth

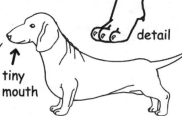

9. Shade.

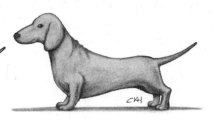

Try and make a super-long doggie!

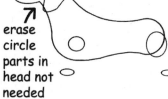

HOT DOG

DEXTER THE CAT

KNOW:
Combine, Overlap, Proportion

UNDERSTAND:
• The use of shading can achieve a more realistic rendering.
• How to create an effective likeness of an oriental shorthair cat.
• Simple shapes combined together can create more complex objects.

DO:
Follow the steps provided and create your own version of Dexter (or your own favorite kitty-cat). Begin by drawing simple geometric shapes and connecting them to create a more complex, organic shape that resembles the breed. Add "extras" like fur texture, whiskers, collar, etc. Shade to indicate form or pattern. Erase areas for highlights.

VOCABULARY:
Combine – Two or more objects put together.

Overlap – When one thing lies over, partly covering something else. Depicting overlap is one of the most important means of conveying an illusion of depth.

Proportion – The proportion relationship of one part to another in an object or the whole object with respect to size, quantity, degree or number.

Dexter is an oriental shorthair. His sleek body, angular head and large flaring ears make him appear unique and exotic.

Dexter the Cat

oriental shorthairs DO have fur!

1. Draw a circle and oval

small circle head

angled oval body

2. Connect the head and body with curved lines

add tiny circle for the chin

3. Add circle for hind leg

angled guides

draw a light guide for the eyes, nose & mouth

overlap →

4. Add front leg and paw

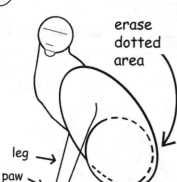

erase dotted area

leg →
paw →

5. Draw eyes on the top guideline

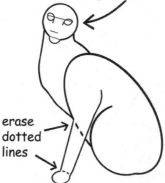

erase dotted lines

6. Draw nose, ears and tail

Detail of nose

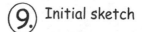

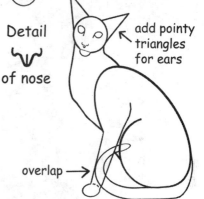

add pointy triangles for ears

overlap →

7. Round the ears and add a curved mouth

Detail of mouth

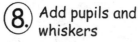

Draw the rest of the legs →

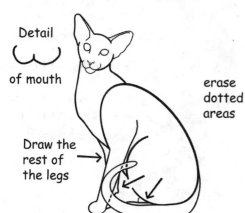

8. Add pupils and whiskers

erase dotted areas

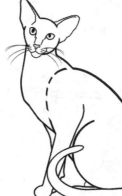

9. Initial sketch

Dexter the Cat SHADING

1. Shade in the areas of dark shadow first

2. Fill in the rest with a medium tone

3. Smooth tones with a blending tool

4. Smooth out any harsh lines and add fur texture around the contour

5. Highlight in the eyes

Darken the nose

Lighten whiskers

Add more contrast in dark areas

Start pattern on tail and body

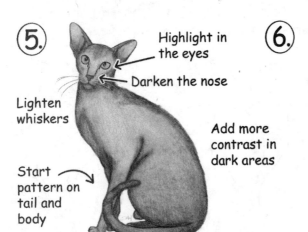

6. Deepen tones for contrast

Erase areas of highlight

Smooth all of the outlines so they are blended

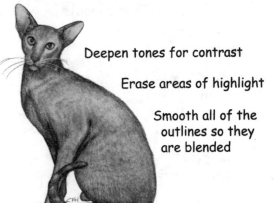

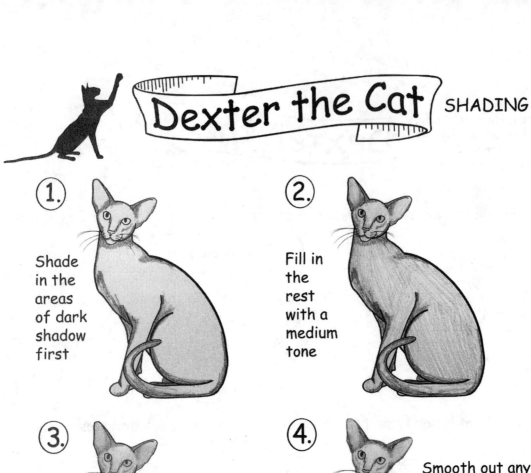

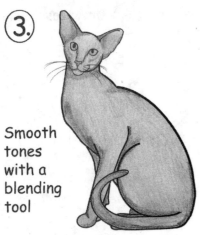

Create a Tattoo

Tattooing has been practiced around the world for thousands of years, reflecting a human need to decorate the body. Tattoos can have a sacred, religious, medicinal and social significance . . . or just be pretty designs.

The next few pages will put your imagination to the test! Pretend you are a custom tattoo artist at "Dexter's Tattoo Shop". You will be able to choose a specific client and create a colorful and imaginative piece from scratch for them based on their artistic requests. There are a variety of subjects to choose from so pick something that is interesting to you. Following the client list, there is a template of a forearm outline in which the design can be created on. Feel free to use this or draw a different body part outline in which the tattoo will be placed. Choose your client and take into consideration their age and interests. This will help you to design the perfect tattoo for them.

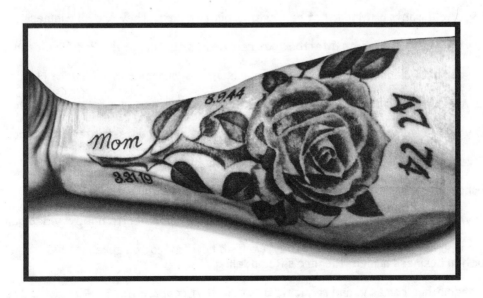

Dexter's Tattoo Client Sheet

Choose a client below then design a tattoo based upon their request on the template provided.

1. A 45 year old woman is getting her first tattoo. She wants something small, yet colorful, to represent her time living in Tokyo, Japan.

2. A 24 year old man asks for a tattoo that represents his apple farming hobby.

3. A 32 year old woman comes in and asks for a tattoo that represents her job lobstering.

4. A female teacher requests a tattoo that represents her twin daughters Charlotte and Taya Cate. They love art, dancing and Roblox.

5. A lady wants a tattoo that represents the spa she works at. Her specialty is manicures.

6. A 68 year old man wants a tattoo that represents his favorite hobby, playing chess.

7. A woman wants a tattoo that represents her favorite vacation destination, the beach.

8. A middle aged man wants a tattoo that represents his favorite pastime, hiking through the woods of New England.

9. A 22 year old woman wants a tattoo to celebrate her boyfriend who is a guitarist in a band named "Chaotic."

10. A man requests a tattoo that represents his wife who is a botanist.

11. A 41 year old wants a tattoo that represents his five cats. They are all Siamese.

12. A 65 year old woman wants a tattoo that represents surfing in the Pacific Ocean.

13. A 38 year old woman wants a tattoo to represent her cupcake shop "Sweet Heart".

14. A 72 year old man wants a tattoo that represents his career as a caterer and chef.

15. A 35 year old woman wants a tattoo that represents her greatest interest, astronomy.

16. A 41 year old man wants a tattoo that represents his hobby as a bee keeper.

17. A grandfather requests a tattoo that commemorates his career as a computer genius.

18. A 29 year old woman wants a tattoo that represents her favorite hobby; video games.

19. A man who has several tattoos already, wants a new tattoo to represent his construction business named "Richard's Remodeling".

20. A grandmother comes in and requests a tattoo that represents the 40+ years she worked as a nurse in the Neonatal Intensive Care Unit.

ARTIST NAME :_____

DATE :_____

CUSTOMER # :_____

LOCATION OF TATTOO :___forearm___

(wrist)

(elbow)

DEXTER'S
Tattoo Shop
123 HOW TO DRAW AVENUE, COOL STUFF, U.S.A.

Notes:

- Your client has offered an idea of what they want but it is up to you to create a one-of-a-kind design.

- Use clear, crisp, even lines to create the artwork. Any shading should be steady and consistent.

- Make sure the design is pleasant to look at – your client will have this art on their body forever!

- Any words used in a tattoo must be spelled correctly. If you aren't sure about the spelling or meaning of a word – look it up.

- After you've decided upon a design, determine if it will be colorful or shaded in black.

- Remember, you are designing this artwork for someone else based upon their request. Your job is to make the client happy!

HUMAN FACE PROFILE

KNOW:
The simple steps to create a human face

UNDERSTAND:
• The use of proportion and guidelines to create a head and generic facial features.
• Subtle differences in the shape and size of specific features that make us look unique.
• Protruding objects (nose, lips, etc.) create shadows.
• The human head can be measured/created on a grid.

DO:
• Practice drawing a generic human face/head using the proposed techniques.
• Start with guidelines, place the features, then shade.

NOTE:
Details on how to draw a human face and create self-portraits can be found in "How to Draw Cool Stuff: A Drawing Guide for Teachers and Students." This lesson offers a quick review of how to draw features of the face but focuses more on creating a generic face to use as a base for creating a design on top of it.

VOCABULARY:
Guidelines – Lightly marked lines used as guides when composing a drawing.

Proportion – The comparative sizes and placement of one part to another.

Human Face Profile

1. Lightly draw a circle with an overlapping, angled oval. These will be the profile guidelines.

overlap

slight angle

2. Erase areas inside as shown. Add curved neck lines.

3. Lightly draw three angled lines as guides. Draw a backwards "C" for the ear.

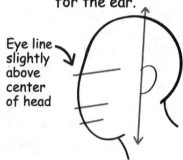

Eye line slightly above center of head

4. Add a nose between the top and middle guide. Draw the upper lip below that.

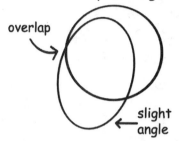

Dents inward

5. Add the bottom lip and extend the chin beyond the guide as shown.

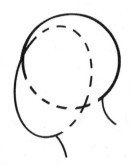

Erase the chin guide-lines

Chin sticks out

6. Add an arch on the top guide for the brow, a triangle beneath for the eye and a nostril.

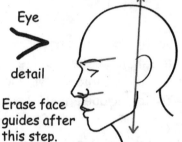

Eye

detail

Erase face guides after this step.

7. Add iris, pupil and cheek line. Start to detail the earlobe.

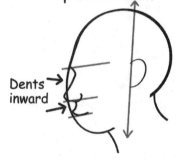

Eye

detail

8. Lightly sketch the hair outline and cheekbone detail.

Notice the hair is not flat/stuck to head

9. Darken the eye and brow area.

Lightly shade the upper lip, under the nose, under the neck, inside ear, temple and hair

CVH

SELF PORTRAIT WITH TEXT

KNOW:
Aspects of identity, Self-portrait

UNDERSTAND:
• Methods of conveying one's identity through artwork using symbols and text
• Identity is multi-faceted and may change over time
• Symbols have different meanings for different viewers
• Symbols can change meaning if put in different contexts
• Art can be for oneself and/or a method of communication

DO:
Brainstorm at least 10 words/images that represent your identity. Draw the silhouette of a head and personalize it by adding text, images, colors, and quotes in a creative manner that embodies your concept of yourself.

TIPS:
• Write words and draw images close to the edge of your profile outline so they take on the shape of that outline.
• Use different fonts/typefaces to add interest.
• Try to include an equal amount of text and images for balance and interest.

VOCABULARY:
Identity – The sense of self; the distinguishing character or personality of an individual.

Self-Portrait – A portrait of oneself created by oneself.

Silhouette – The shape or outline of something, void of detail in the middle.

Typeface/Font – A set of letters, numbers, etc., that are all in the same style used in printing or writing.

Essential Questions:
• Who are you?
• How do you know who you are?
• What makes me – me?
• How can I share/show who I am with others?
• What symbol can I create that represents who I am now or who I desire to become?
• Who is my art for? (Who is my viewer/who is my audience?)

216

These steps are only an example. Use your OWN answers for "Who am I"

Text Self Portrait

1. Brainstorm at least 10 answers to the question "Who am I ?"

1. animal lover
2. part of a family
3. runner
4. reader
5. artist
6. internet surfer
7. shoppper
8. napper
9. dreamer
10. swimmer

2. Outline a face profile or have your friend trace your own profile.

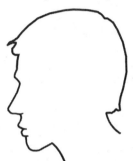

3. Write or draw one of your words inside of the head shape.

If writing, use block, bubble or other types of letters that are not "stick" letters

4. Write another word or draw a symbol/image that represents a word from your list.

5. Add another word or image.

Notice how the words curve around the inner profile

6. Keep adding images and words inside the profile.

7. Fill entire head. Add designs or other interesting items that describe yourself for filler.

8. Color or shade.

217

HUMAN HEAD

KNOW:
The simple steps to create a human face

UNDERSTAND:
• The use of proportion to create a head and generic features.
• The subtle differences in the shape and size of specific features make us look unique.
• Protruding objects (nose, lips, etc.) create shadows.
• The human head can be measured/created on a grid.

DO:
• Practice drawing a generic human face/head using the proposed techniques.

NOTE: Details on how to draw a human face and create self-portraits can be found in "How to Draw Cool Stuff: A Drawing Guide for Teachers and Students." This lesson offers a quick review of how to draw features of the face but focuses more on creating a generic face to use as a base for a design we will later draw on top of it.

VOCABULARY:

Proportion – The comparative sizes and placement of one part to another.

Self-Portrait – A portrait of oneself, created by oneself.

A Basic Human Face

1.

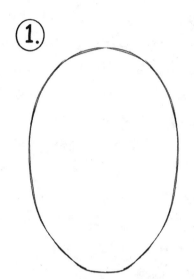

Start with an oval or "upside down" egg shape. The top part should be slightly fuller.

2.

Make a lower case letter "t" in the center of the face.

3.

Put your finger in the center of the "t" and your other finger on the chin. Find the center and draw a line there. This will be the bottom of the nose.

4.

Put your finger in the center of the line you just made and your other finger on the chin. Find the middle, make one last line. This will be the mouth.

5.

On the top line, draw two almond/football shapes for the eyes.
TIP: The distance between the eyes is about the width of one eye.

6.

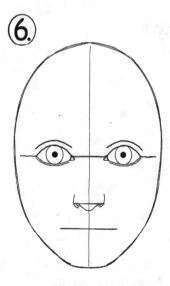

Add the iris, pupil, eyelids, etc. On the second line, draw the bottom of the nose.
TIP: The width of the bottom of the nose is about the same as the width between the eyes.

⑦

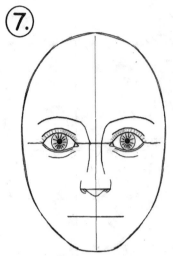

Add "spokes" in the iris and lines for the brows and sides of the nose. TIP #1: The sides of your nose are connected to your brows! TIP #2: The fattest part of the nose is the base, the thinnest part is between the brows. (think triangle shaped)

⑧

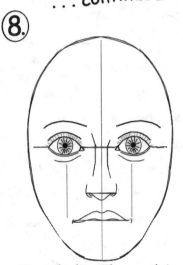

Start the lips. The mouth is usually as wide as the distance between the pupils.
TIP: Don't forget to add the "Cupid's Bow": the little divit at the top of the upper lip.

⑨

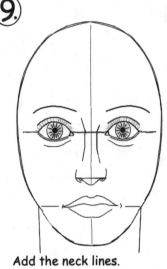

Add the neck lines.
TIP: The neck is about as wide as the edges of the mouth lines.
Add the bottom lip.
TIP: The bottom is usually fuller than the upper on MOST people.

⑩

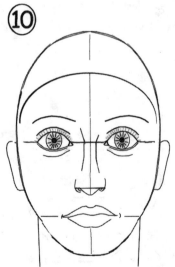

Add the hairline (looks like a swim cap). Add the ears.
TIP: The top of the ear lines up with the eye line, the bottom of the ear lines up with the bottom of the nose.

⑪

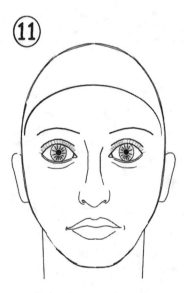

Erase the guidelines.

⑫

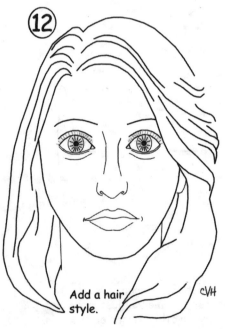

Add a hair style.

CVH

DESIGNING SUGAR SKULLS

KNOW:
Dia de los Muertos, Sugar Skull, Symmetry

UNDERSTAND:
• The use of proportion and guidelines to create a head and generic facial features.
• The meaning and uses of sugar skulls related to Mexican culture.
• Popular designs used when creating sugar skulls.

DO:
• Practice drawing a generic human face/head using the proposed techniques.
• Explore the tradition of using and decorating sugar skulls. Then, create an original sugar skull composition based on popular designs.

TIPS: The symbolism of a sugar skull is rooted in the decoration around the eyes. Flowers are meant to symbolize life, while cob webs symbolize death. Burning candles set inside the eyes are a sign of remembrance. These items can also be used in combination to personalize the main focus of the skull. If you're having trouble coming up with ideas on how to adorn your sugar skull, just choose designs or images that you like or check out the ideas on page 221.

NOTES: These tutorials show a few popular ideas for creating sugar skull compositions on a female face and a male face followed by an idea page which offers some other popular sugar skull designs. A basic human face and basic skull tutorial are also included. Following the tutorials are templates that can be copied to draw designs directly onto in the case that the artist does not want to draw the human face or skull as a base.

VOCABULARY:
Dia de los Muertos – A traditional holiday on November 1st and 2nd where Mexican families celebrate the lives of their dearly departed friends and relatives.

Sugar Skull – Sugar skulls are art pieces often made in Mexico created using molded sugar, feathers, beads, foil and icing to decorate gravestones in celebration of The Day of the Dead (Dia de los Muertos). Sugar skulls are made from very few ingredients - sugar, meringue powder, and water. The mixture is pressed into a mold and allowed to dry, creating a plain white three-dimensional skull. The artistic part of sugar skull creation is how it's decorated once the molded skull is formed.

Symmetry – The parts of an image or object organized so that one side duplicates or mirrors the other.

Calaveritas (sugar skulls) have colorful icing sugar and are often displayed on ofrendas, altars made for loved ones who have passed

Sugar Skull
Girl

①.

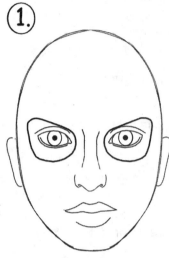

Start with a basic face outline. Draw a circular shape around the eye area to indicate eye sockets.

②.

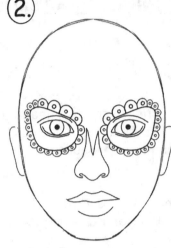

Add designs around the circular shape. Draw an inverted triangle on the nose to look like a nasal septum.

③.

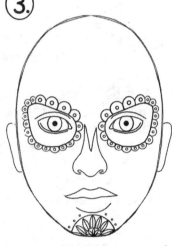

Next, add a design on the chin area. This is often drawn as a partial flower.

④.

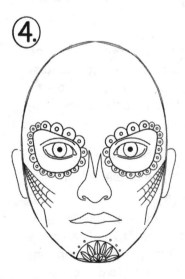

Indicate cheekbones using swirls, spiderwebs or dark colors blended down toward the jawline.

⑤.

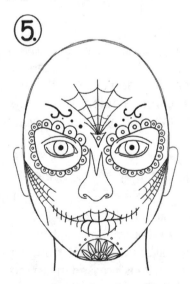

Draw "stitches" across the mouth area and a swirl or spiderweb design on the forehead.

⑥.

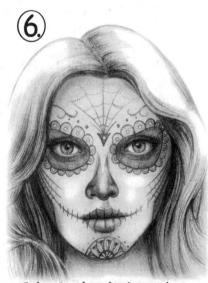

Color in the design using contrasting shades so the features really stand out. Add lots of "extras".

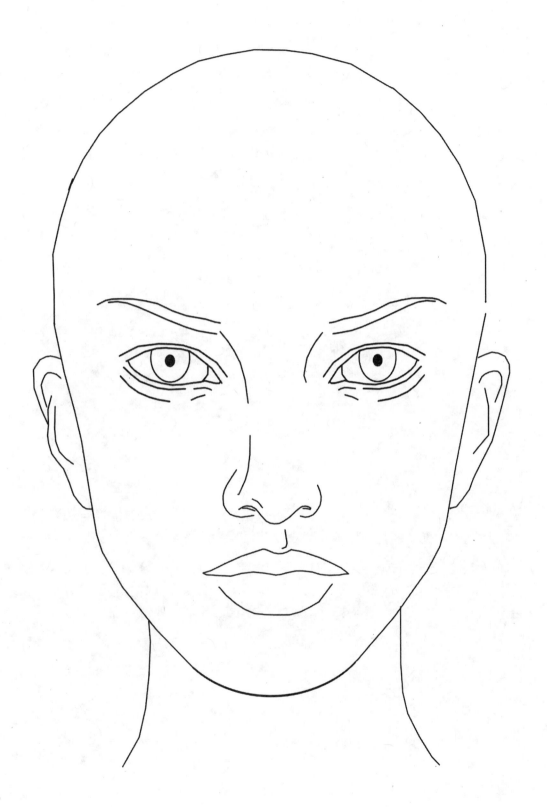

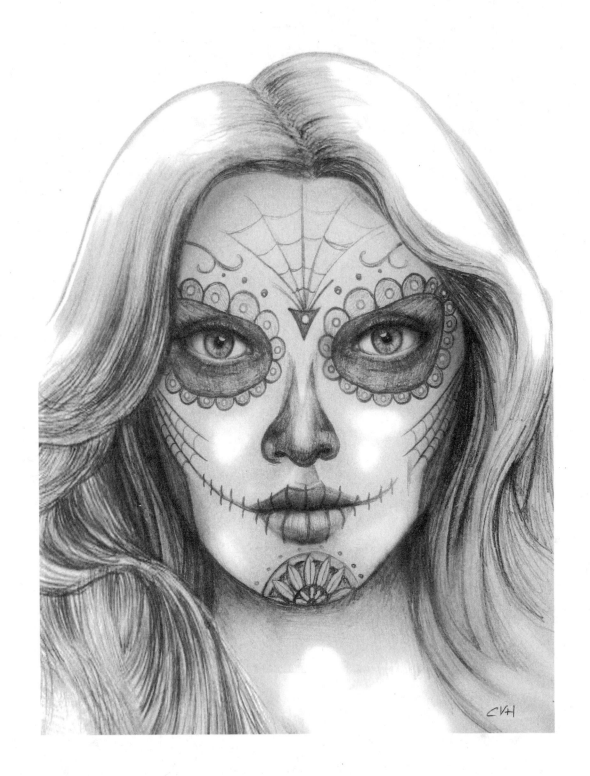

Traditionally, sugar skulls are created as ornamental gifts for children and family during Día de los Muertos

Sugar Skull
Guy

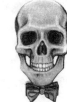

1.

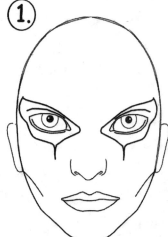

Start with a basic face. Draw a shape around the eye area. This will later be shaded in with a dark color.

2.

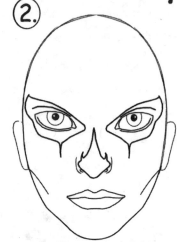

Outline the nose with an upside down triangular shape. This can be embellished to make it look more interesting.

3.

Next, add a design on the chin area. On males, this is often shown as a simple geometric shape, spiderweb or swirl.

4.

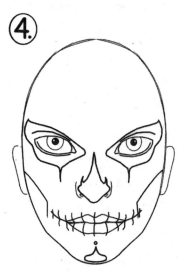

Draw "stitches" across the mouth. These lines should extend beyond the mouth and stretch towards the cheek area.

5.

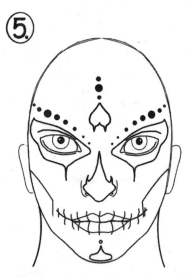

Add simple shapes, swirls or spiderwebs to the forehead. Embellish as desired.

6.

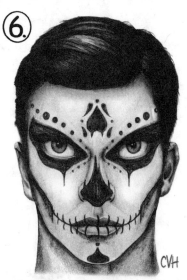

Color in the design using contrasting shades so the features really stand out. Add lots of "extras".

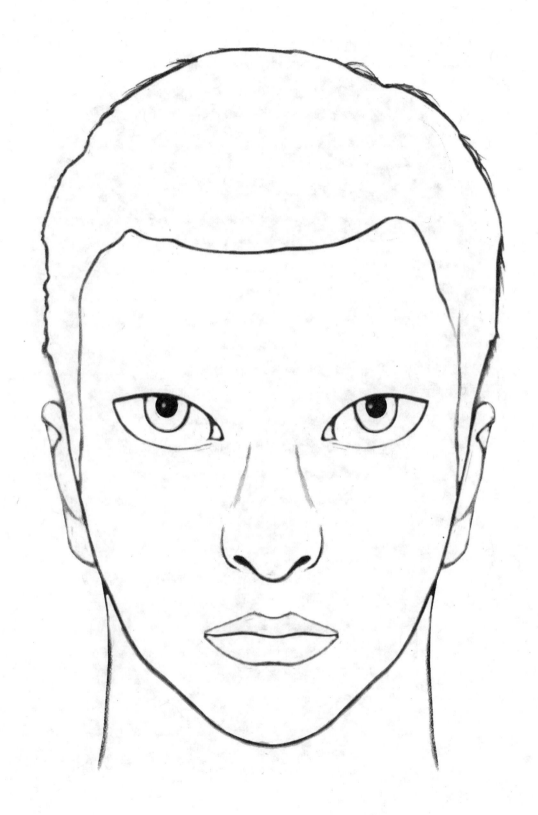

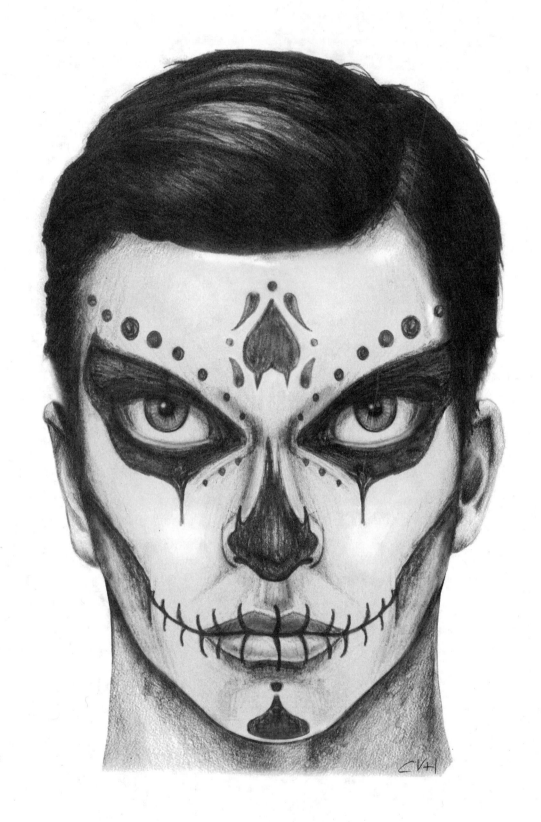

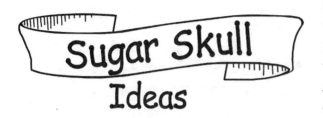

Sugar Skull
Ideas

Below are some popular decorations that have been used to create Sugar Skulls. There are millions of designs that can be made - this is just a tiny sampling! Use these as inspiration to draw your own, unique Sugar Skull .

Some options for a nose decoration . . .

Eyes . . .

Forehead designs . . .

Mouth options . . .

Chin options . . .

Embellish other areas with roses, swirls, dots and flowers . . .

THE HUMAN SKULL

KNOW:
• Balance, Proportion and Symmetry

UNDERSTAND:
• The simple drawing steps used to create a realistic human skull.
• Major bones of the head.
• Features of the human head can be measured/created on a grid.

DO:
• Practice drawing a generic human skull using the proposed techniques.

VOCABULARY:

Balance – The way an artwork is arranged to create a feeling of stability; a pleasing or harmonious arrangement or proportion of parts or areas in a design or composition.

Cranium – Portion of the skull that encloses the brain case.

Human Skull – Supports the structures of the face and forms a cavity for the brain.

Mandible – The lower jawbone.

Proportion – The comparative sizes and placement of one part to another.

Symmetry – Parts of an image or object organized so that one side duplicates or mirrors the other; the same on both sides.

Draw a Human Skull

1. Start with a circle.

2. Add a rectangle.

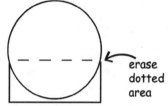

erase dotted area

3. Add jawline.

angle lines at points

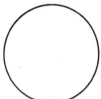

4. Round edges.

add curve

round and erase sharp edges

5. Add eyes, nose and mouth.

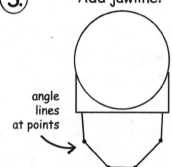

add eyes

"house" shaped nose

smile

6. Define the mouth area.

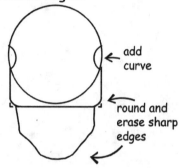

erase dotted areas

add "arrow" points

add two slightly curved "teeth" lines

7. Add details as shown.

curve tops of teeth

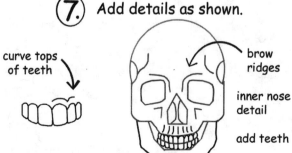

brow ridges

inner nose detail

add teeth

8. Smooth out the hard lines.

Smooth out the hard edges and round off any pointed lines

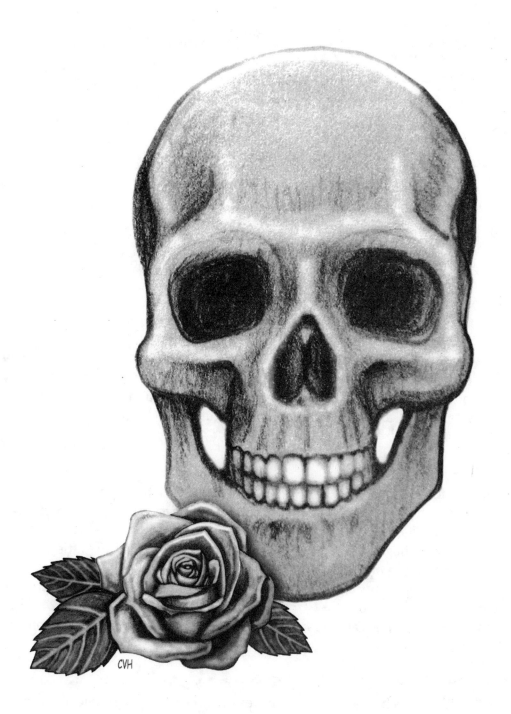

CVH

DRAW SOMETHING WICKED

KNOW:
- You can create a complex, original character by using simple, geometric shapes
- Adding details and embellishments to a generic drawing can make a unique artwork

UNDERSTAND:
- To make a work original, that work must have elements that are not copied or traced.
- Expressive qualities in your drawing add a feeling, mood or idea to your character.
- A detailed backstory describing the character you create will add interest.

DO:
Practice creating an original character using the provided samples as inspiration. Draw lightly so guidelines can be erased if needed. Add or change certain elements as necessary to make it unique. Combine several elements seen in the lesson or make up your own to create a character, name, and story NOT seen on the tutorial. Use your imagination and add a lot of "extras".

TIPS:
- Choose a name for your character. This will help to personalize him or her.
- Think about the kind of impact you want your creature to have. What are its goals? Why does it look the way it does?
- Accessories can be a huge part of your character. Take time to plan the little "extras" your character is wearing or uses.
- Develop the creature's history and background: where it came from, how it was created and why it acts the way it does.
- To get inspiration, take a peek at the sample characters and body parts in this lesson, but put your own spin on them to make it original!

VOCABULARY:
Expressive Qualities – The feelings, moods and ideas communicated to the viewer through a work of art.

Original – Any work considered to be an authentic example of the works of an artist, rather than a reproduction, imitation or a copy.

This is a list of ideas for your creature... use parts that you like and make up the rest!

Draw Something Wicked
part I

1. Choose a head shape. There are thousands to create - these are just a few ...

pointy oval furry exposed brain bumpy

2. Next, create an expressive set of eyes (or just one eye - you pick!)

rolled back giant pupil skinny pupil no pupil reptile-like two eyes in one

round reptile tube drippy angry surprised claw lashes

3. Choose a scary mouth. Extra points for lots of teeth and dripping saliva!

pointy smiles

foamy vomit

cracked

wide open

vampire fangs

toothy worm underbite fangs clenching teeth happy pointers

Draw Something Wicked
part II

④ Pick a nose ;)

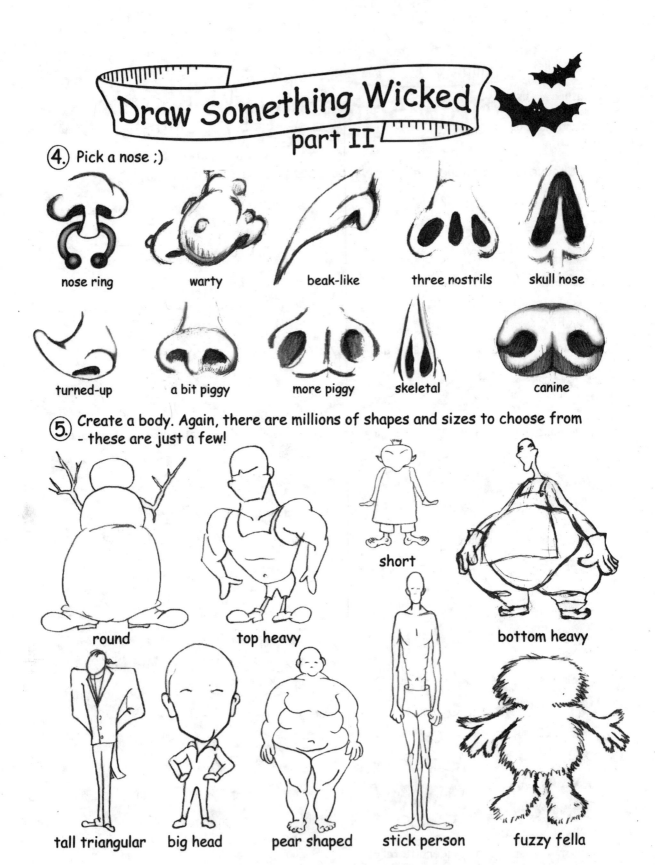

nose ring warty beak-like three nostrils skull nose

turned-up a bit piggy more piggy skeletal canine

⑤ Create a body. Again, there are millions of shapes and sizes to choose from - these are just a few!

round top heavy short bottom heavy

tall triangular big head pear shaped stick person fuzzy fella

Sin-derella

A former beauty queen, SinDerella lurks in the cemetery after midnight to dig up the buried and steal their jewelry.

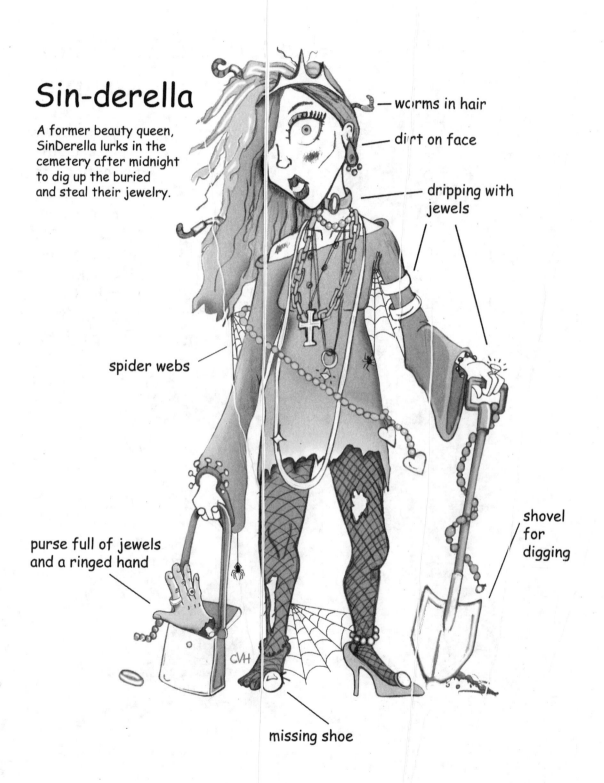

worms in hair

dirt on face

dripping with jewels

spider webs

purse full of jewels and a ringed hand

shovel for digging

missing shoe

Hector the Hip-Hop Zombie

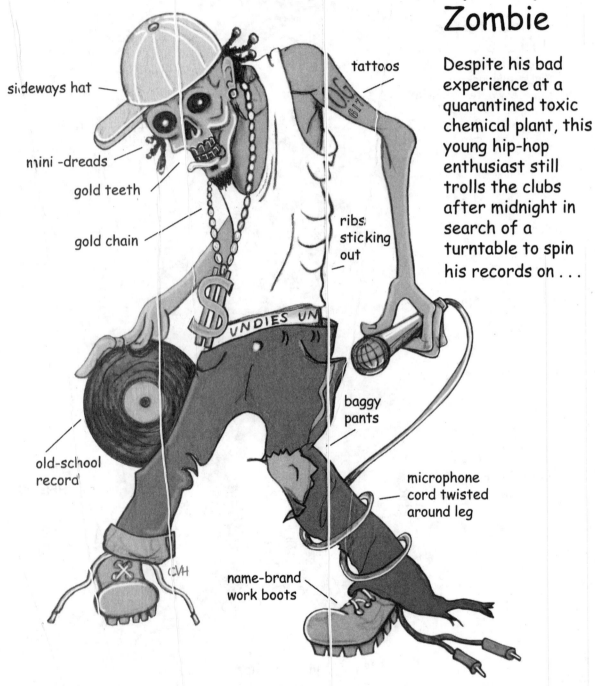

sideways hat

mini-dreads

gold teeth

gold chain

old-school record

tattoos

ribs sticking out

baggy pants

microphone cord twisted around leg

name-brand work boots

UNDIES UN

Despite his bad experience at a quarantined toxic chemical plant, this young hip-hop enthusiast still trolls the clubs after midnight in search of a turntable to spin his records on . . .

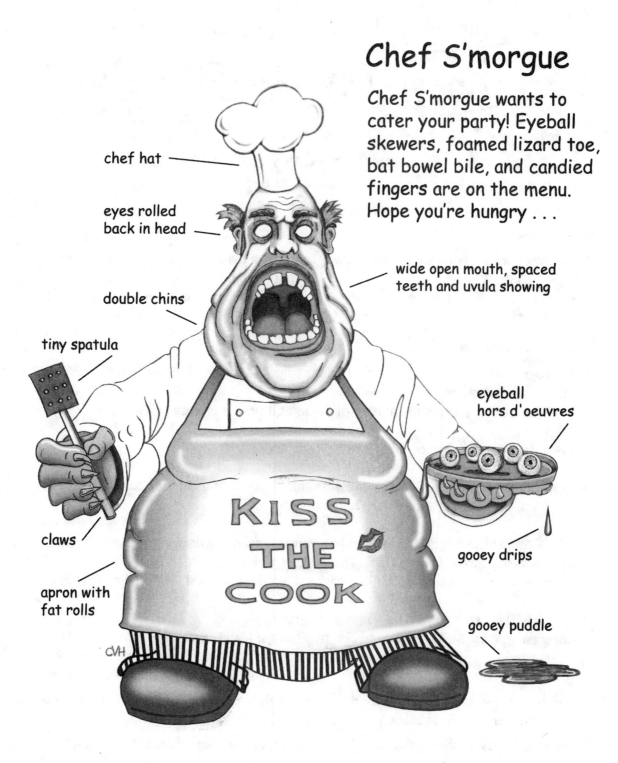

Chef S'morgue

Chef S'morgue wants to cater your party! Eyeball skewers, foamed lizard toe, bat bowel bile, and candied fingers are on the menu. Hope you're hungry . . .

chef hat

eyes rolled back in head

double chins

tiny spatula

wide open mouth, spaced teeth and uvula showing

eyeball hors d'oeuvres

claws

gooey drips

apron with fat rolls

gooey puddle

KISS THE COOK

CVH

KITTY CAT FACE
on black paper

KNOW:
- Texture
- Using contrast in drawings is a great way to create a dynamic image. One way of creating good contrast is by using white material or media on dark or black surfaces
- Black paper offers a number of challenges but also provides some interesting alternative approaches

UNDERSTAND:
- Recognize the importance of tints (lighter values) and their inherent relationships with shades (darker values).
- With practice, our understanding of value and how it is used to create drawings will improve.
- How to create intense contrast.

DO: Create an original artwork showing the features of a cat face following the steps provided. Use shading and texture to create interest.

TIP: (If using black paper) Normally, when you are creating a drawing you would draw with dark material onto a white surface. This process is the opposite as you will be adding light values to the surface and leaving the dark values alone, almost like drawing in reverse.

VOCABULARY:
Contrast – A large difference between two things; for example, hot and cold. This term refers to a way of juxtaposing elements of art to stress the differences between them. In this artwork, the contrast comes from the colors black and white.

Invert – To reverse the order or condition of something such as when making what is black white and what is white black.

Texture – The way something looks like it might feel like in an artwork. Simulated textures are suggested by an artist with different brushstrokes, pencil lines, etc.

 Kitty Cat Face

①.

Start with two "football" oval shapes - Place the ovals about 1/3 of the way down from the top of your paper.

②. Add two skinny ovals inside the "footballs".

Add a capital letter "T" for the nose

③.

Curve the sides of the "T" top. Add a wide "W" touching the base the the "T" shape.

④.

Add a 1/2 circle for the chin. Add curves for nostrils.

⑤. Cats have 130,000 hairs per square inch. We will draw just a few.

Shade above nose →
Close the nose → with a "U" shape

SHADE LIGHTLY!

⑥.

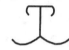

Lightly → shade nose mouth and chin

tiny fur lines

⑦. Color the eyes.

a. → black pupil with yellow iris

b. ← draw a thin layer of brown along the top

c. ← blend green around pupil

d. Add white highlights

⑧.

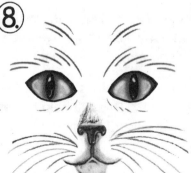

Add curved whiskers coming from cheek area (some short, some long)

⑨.

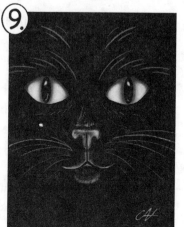

241

RUBE GOLDBERG INSPIRED MACHINE

KNOW:
- Process of Invention
- Rube Goldberg
- "Cause and Effect"
- Motions, Forces and Transfer of Energy

UNDERSTAND:
- How machine parts can work together to create a simple task.
- Newton's Laws of Motion.
- Abilities of technical design.
- Backwards planning to accomplish a goal.
- How to design, problem solve, and illustrate a simple machine.

DO:
- Observe, read and interpret examples of Rube Goldberg Machines.
- Decide what simple everyday task your machine will complete, then design a device using at least 10 different items that accomplishes that task using maximum effort to achieve minimal results.
- Create an explanation of what task the device accomplishes or write a creative story that incorporates your new device.

TIP: The process of invention requires beginning with the end goal, or the last thing that needs to happen. Decide what the goal should be, then begin working backward, creating as many steps as possible to accomplish the final task.

When creating the machine, ask questions such as: "Can this object launch or move that object?" or "Will this object roll?" This will help to determine which items to use to accomplish the task. Write down a list of any possible objects to use that will help.

VOCABULARY:
Action – When something done or performed; the accomplishment of a thing, usually over a period of time in stages.

Device – A thing made for a particular purpose.

Invent – o create with the imagination or produce a product of one's own ingenuity, experimentation, or contrivance; to create or produce (something useful) for the first time.

Energy – Exertion of power.

Rube Goldberg – Pulitzer Prize-winning cartoonist who is best known for his "invention" cartoons which use a series of steps and objects to accomplish everyday simple tasks in the most complicated way. Goldberg's drawings point out that people are often overwhelmed by over-complicating their lives.

"Machine" Parts

1. Draw a conveyor belt to move items from one area to another.

2. A roll of tape can be used to roll into an item when pushed or it can stick to things.

3. A ball can roll down a chute and knock something over.

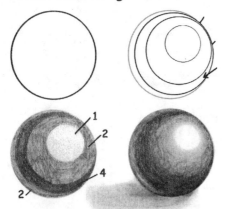

4. A spray can can be activated to create wind or make something sticky.

5. A candle can be lit to burn through piece of string.

6. A bird can fly away with something.

More "Machine" Parts

bucket on a pulley

toy car

fan

weighted scale

racket and ball

bell

popping balloon

anvil

digger

pouring bucket

coiled spring

swinging mallet

chute

A simple tube

bend

steam

245

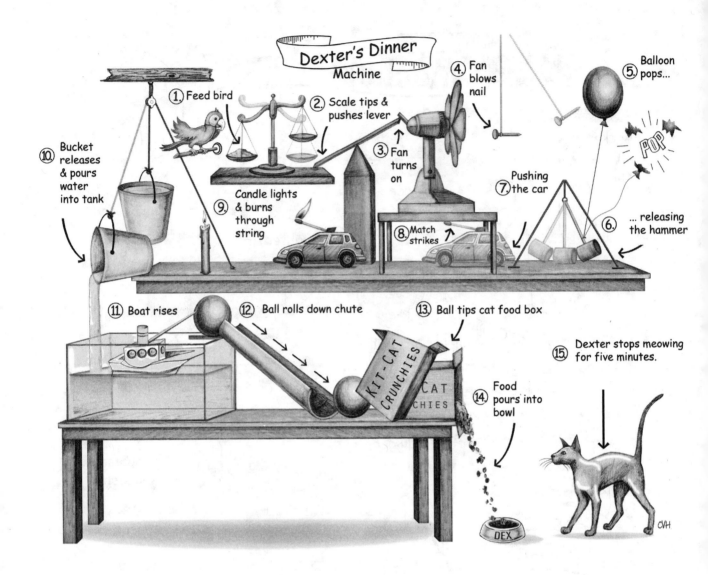

Dexter's Dinner Machine

1. Feed bird
2. Scale tips & pushes lever
3. Fan turns on
4. Fan blows nail
5. Balloon pops...
6. ... releasing the hammer
7. Pushing the car
8. Match strikes
9. Candle lights & burns through string
10. Bucket releases & pours water into tank
11. Boat rises
12. Ball rolls down chute
13. Ball tips cat food box
14. Food pours into bowl
15. Dexter stops meowing for five minutes.

KIT-CAT CRUNCHIES

DEX

POP

EPILOGUE

We use creativity every day in every aspect of our lives: from creative problem-solving to the simple appreciation of beauty. *Creating* provides a platform to explore experiences within yourself, and helps communicate information to others. Whether the goal is to become a skilled artist, create a likeness, express a feeling, or simply make interesting things, drawing is a great way to improve concentration, express individuality, and provide pleasure for yourself.

The ability to draw is a skill that is learned, not a gift we are born with. Everyone has the potential to become a skilled artist through practice and patience. As always, the more time spent practicing a task, the better the result will be. Therefore, if time is spent practicing drawing skills, those skills will eventually become better and better. The growth and improvement resulting from creating never stops as long as there is a desire to create.

The lessons in "How to Draw Cool Stuff" offer guidelines to follow for the creation of specific objects. This does not necessarily mean these ideas should be copied exactly as they are printed without deviation from the original. Sometimes it is necessary to copy when first learning how to draw a specific object—even tracing can be an acceptable practice as one is learning how to draw. However, it is important not to be too concerned with trying to make your drawing look just like the one in the book. Your unique and sometimes imperfect approach is what will make your work of art engaging and beautiful. It is important to see what will happen when creating a work of art rather than trying to make something specific happen. The process of experimentation and practice is priceless. An idea that you start with can turn into something completely different. If this begins to happen, let it. Create whatever your art desires without the pressure of doing things like everyone else.

Once an artist becomes engaged in the process of creating, beautiful and unique things can happen. Oftentimes, the process of creating is even more valuable than the outcome. The act of drawing can offer an escape from reality, a way to pass the time, a way to relax, and become something enjoyable to do.

It is important to explore and experiment as you draw. One obstacle that can be difficult to overcome as one draws is the idea of what other people think. Worrying about this and comparing your work to another person's art can be less than productive. In fact, this can be detrimental if it makes you feel bad about your own work. Being aware that there's room for improvement can be healthy; however, becoming discouraged from pursuing art because you feel like you'll never be as good as other artists is debilitating. Try not to do this. What you have to offer is what makes an artwork interesting. There may be times that you feel stuck in your progress or blocked from proceeding any further. Know that this happens to everyone. If you feel like you are getting stuck, take a break and have patience with yourself. The unique path one person takes while creating can be very different from someone else's. That is the beauty of art. We all have different ideas, methods, and approaches to drawing, and that is what makes art so wonderful.

Forget about the idea of needing so-called talent, or gaining accolades and awards for your work. Just draw. When participating in the process of creating without rigid expectations or preconceptions, the power of drawing comes alive.

Creativity is a part of our everyday lives. Art fosters the need for creative problem solving, innovation, reasoning creatively, and envisioning multiple solutions to dilemmas. These skills are beneficial to employers and colleges but are also necessary in life. Most importantly, having a creative outlet makes us happy. Make time in your week to spend a bit of time drawing your own "cool stuff" and don't worry about the final product.

Enjoy the journey!

The How to Draw *Cool Stuff* Series

For more in-depth lessons and a variety of fun projects, be sure to get a copy of the first book in the series, **"How to Draw Cool Stuff: A Drawing Guide for Teachers and Students."** This book is filled with valuable tips, step-by-step instructions, and creative exercises that will help you take your drawing skills to the next level.

Additionally, if you want to delve deeper into the nuances of light and shadow, bringing your drawings to life with a sense of realism and depth, our book **"Drawing Dimension: Shading Techniques"** is an excellent resource. This book will guide you through the intricate details of shading, helping you master the art of creating lifelike textures and forms

"How to Draw Cool Stuff: Holidays, Seasons and Events" celebrates the joy and spirit of various festive seasons through art, offering you a chance to explore thematic drawing. Whether you're drawing Halloween pumpkins, Christmas trees, or summer beach scenes, you'll find inspiration and techniques to enhance your artistic skills and enjoy the festive spirit year-round.

"The 5 Minute Workbook" is a perfect companion for honing your skills, focusing on quick, effective exercises to improve your shading and observational drawing. Each exercise is crafted to enhance your technical abilities and boost your confidence, allowing you to see noticeable improvements in a short amount of time.

Do you have a little Picasso at home who is fascinated by the world of cute and cuddly creatures, enticing food, and lovable aliens? This fun and engaging guide is designed to introduce children aged 6 to 11 to the art of drawing. Perfect for developing motor skills and nurturing artistic confidence, each page brings new adventures in cuteness to life. Let your child's imagination soar with this magical journey into the realm of cute and cuddly creations.

Discover the dark and imaginative world of drawing with **"How to Draw Awesome Stuff."** Perfect for adults, this book teaches how to create creepy and scary images that are sure to give your friends and family nightmares. With easy-to-follow tutorials, you'll learn how to recognize the basic shapes within objects and use these shapes to create images that are both dynamic and visually stunning.

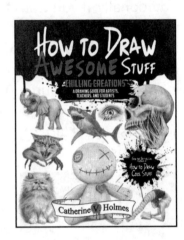

These books, and the many more to come, are invitations to continue your exploration of drawing, to push the boundaries of your creativity, and to express your unique vision through art.

I encourage you to explore the entire series, to find new challenges, and to discover new joys in drawing.

Thank you for allowing me to be a part of your creative journey. May your pencils stay sharp, your erasers stay soft, and your pages be filled with the cool stuff you love to draw!

CATHERINE V. HOLMES
Author
How to Draw Cool Stuff
www.HowToDrawCoolStuff.com